Building Multicopter Video Drones

Build and fly multicopter drones to gather breathtaking video footage

Ty Audronis

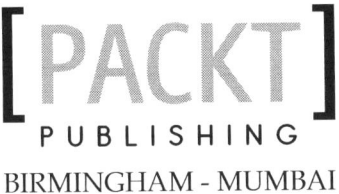

PUBLISHING
BIRMINGHAM - MUMBAI

Building Multicopter Video Drones

Copyright © 2014 Packt Publishing

All rights reserved. No part of this book may be reproduced, stored in a retrieval system, or transmitted in any form or by any means, without the prior written permission of the publisher, except in the case of brief quotations embedded in critical articles or reviews.

Every effort has been made in the preparation of this book to ensure the accuracy of the information presented. However, the information contained in this book is sold without warranty, either express or implied. Neither the author, nor Packt Publishing, and its dealers and distributors will be held liable for any damages caused or alleged to be caused directly or indirectly by this book.

Packt Publishing has endeavored to provide trademark information about all of the companies and products mentioned in this book by the appropriate use of capitals. However, Packt Publishing cannot guarantee the accuracy of this information.

First published: August 2014

Production reference: 1190814

Published by Packt Publishing Ltd.
Livery Place
35 Livery Street
Birmingham B3 2PB, UK.

ISBN 978-1-78217-543-8

www.packtpub.com

Cover image by Aashish Variava (aashishvariava@hotmail.com)

Credits

Author
Ty Audronis

Reviewers
Taylor Coulthard
Lenz Grimmer
Dale Musser, PhD

Commissioning Editor
Edward Gordon

Acquisition Editor
Subho Gupta

Content Development Editor
Vaibhav Pawar

Technical Editor
Madhuri Das

Copy Editors
Roshni Banerjee
Dipti Kapadia
Deepa Nambiar
Stuti Srivastava

Project Coordinator
Kranti Berde

Proofreaders
Ameesha Green
Kevin McGowan
Lucy Rowland

Indexers
Mariammal Chettiyar
Rekha Nair
Tejal Soni
Priya Subramani

Production Coordinator
Kyle Albuquerque

Cover Work
Kyle Albuquerque

About the Author

Ty Audronis has over a decade of experience in radio-controlled videography and cinematography and over two decades as a professional in the entertainment industry. He has shot footage for Investigation Discovery, Travel Channel, and countless other productions. He also runs his own production company, Audronis Media. Ty has also written many magazine articles on multicopter and drone videography and has acted as a consultant on many productions. He has also taught at several film schools and University classes on production and post-production processes (as well as the Internet technology). His education is in Computer Animation and Special Effects, and he has also written the book, *Lightning Fast Animation with Element 3D*, *Packt Publishing*. He is also an expert on visual technology and workflows. For more information on Ty, please feel free to visit http://www.audronis.com.

About the Reviewers

Taylor Coulthard is an avid multicopter enthusiast, who has successfully incorporated quadrocopters into several high-level University courses. These project-based courses have a focus on the automation of the copter for personal use and performing repetitive tasks.

Taylor is very interested in the tech industry and has worked at Recon Instruments, developing wearable technology for alpine sports and triathletes. He has experience working with app development, software, and hardware.

Taylor plans to graduate in 2016 and will pursue a career in automated mechanical systems.

> I'd like to thank my colleague, Jarrod, for supporting my passion for quadrocopters while others doubted it.

Lenz Grimmer lives in Hamburg, Germany. He has a degree in Computer Science and has been enjoying tinkering with electronic circuits since his early teens. He currently works as a product manager for TeamDrive Systems, a company that builds a file sync and share solution with built-in end-to-end encryption. Previously, he has worked at Oracle, Sun Microsystems, MySQL AB, and SUSE Linux.

In early 2010, he first learned about DIY quadrocopters from a conference abstract for the FrOSCon 2010 conference in Germany, and was immediately hooked. A combination of hacking the hardware and the software together with building and flying an UAV was exactly the kind of hobby he was looking for.

After reading countless web pages and forum threads, he realized that there is a steep learning curve involved in getting started with this hobby, especially for beginners who aren't familiar with the countless acronyms involved. Lenz decided to share what he had learned so far and submitted a talk about *Building Quadrocopters* to the invitation-only SAPO Codebits 2010 conference in Lisbon, Portugal. His talk and related video (`http://videos.sapo.pt/HZSIm9FUl3D3bfqmVcsv`) turned out to be very popular; the slide deck on SlideShare (`http://www.slideshare.net/LenzGr/how-to-build-your-own-quadrocopter`) has received more than 40k views by now.

In the meanwhile, Lenz has built several multicopters of various sizes and shapes, most of them powered by the open source MultiWii controller firmware. Recently, he also started looking into controlling model planes and flying wings with on-board flight controllers.

You can find him on many forums dedicated to these topics as LenzGr, even though he usually just lurks and learns from the experiences of others.

Dale Musser, PhD, is an associate teaching professor of Computer Science and the Director of the Information Technology degree program at the University of Missouri. He has previously worked in the education, entertainment, and game software development industries. His PhD is in Instructional Design and Technology from the Ohio State University. His research and development work includes unmanned aerial systems, mobile application development, web technologies, and programming languages.

www.PacktPub.com

Support files, eBooks, discount offers, and more

You might want to visit `www.PacktPub.com` for support files and downloads related to your book.

Did you know that Packt offers eBook versions of every book published, with PDF and ePub files available? You can upgrade to the eBook version at `www.PacktPub.com` and as a print book customer, you are entitled to a discount on the eBook copy. Get in touch with us at `service@packtpub.com` for more details.

At `www.PacktPub.com`, you can also read a collection of free technical articles, sign up for a range of free newsletters and receive exclusive discounts and offers on Packt books and eBooks.

`http://PacktLib.PacktPub.com`

Do you need instant solutions to your IT questions? PacktLib is Packt's online digital book library. Here, you can access, read and search across Packt's entire library of books.

Why subscribe?

- Fully searchable across every book published by Packt
- Copy and paste, print and bookmark content
- On demand and accessible via web browser

Free access for Packt account holders

If you have an account with Packt at `www.PacktPub.com`, you can use this to access PacktLib today and view nine entirely free books. Simply use your login credentials for immediate access.

Table of Contents

Preface	1
Chapter 1: What is a Multicopter?	5
How do multicopters fly?	6
A multicopter's yaw control	7
The principles of multicopter lift	8
How a multicopter moves	8
What's in a multicopter?	10
The airframe	10
Motors and propellers	11
The electronic speed control	12
The guidance system (the brain)	13
Camera gimbals and transmitters	15
Radio systems	16
Summary	17
Chapter 2: Buying a Turnkey System	19
Why choose a turnkey system?	19
If someone is selling it, it probably works … right?	20
Where to look for reviews and advice you can trust	21
Online communities – the new consumer reports	22
RCgroups.com – the largest of the communities	23
YouTube.com – your source for user reviews, warnings, and tests	23
Other sites that can be used	24
What to expect for your budget…	24
Setting realistic expectations	24
Brands you can trust	25
For GoPro shooting	26
Bigger cameras	27
Summary	28

Table of Contents

Chapter 3: Choosing Your Components — 29
What kind of drone should I build? — 29
- How many rotors should it have? — 30
- Redundancy versus stability — 30
- The calculations you'll need — 31

Choosing your airframe — 32
- Carbon fiber versus aluminum — 32
- Choosing your propellers — 34
- Selecting your motor — 36
- Selecting the ESCs — 38
- Powering your multicopter – the battery — 40
- Tweaking your specifications for better results — 42

Delving into camera gimbals — 44
The multicopter brain – the guidance system — 48
- Multicopter guidance system sensor types — 48
 - Global Positioning System — 48
 - The compass — 50
 - Measuring your altitude — 51
 - Keep your attitude in check — 52
- The CPU of your brain — 53
- The final choice for guidance — 53
 - X-Aircraft — 54
 - ArduPilot (APM:chopper) — 54
 - DJI — 54

The human interface — 56
The final component list and cost — 57
Summary — 58

Chapter 4: Assembling Your Drone — 59
Building the airframe — 59
Connecting components — 61
- Connecting a brushless motor — 61
- What's a CAN bus? — 62
- Placing the sensors — 63

Programming your guidance system and remote — 64
- Update! — 64
- Exploring the WooKong software — 65
 - Setting your motor configuration — 66
 - Mounting — 67
 - RC calibration — 68
 - Motor settings — 69
 - Setting up your batteries — 70

Summary — 71

Table of Contents

Chapter 5: Flying Your Multicopter — **73**
- **Get a simulator!** — **73**
 - Thinking in three dimensions — 74
- **Safety** — **74**
 - Where to fly — 75
 - When to fly — 75
 - How you should fly — 75
- **The preflight checklist** — **76**
- **Your multicopter's maiden flight** — **77**
 - Battery calibration — 77
 - Arming and flying your multicopter — 79
 - What is ground effect? — 79
 - Watch out for prop wash — 82
 - Take it slow — 82
- **Summary** — **82**

Chapter 6: First Person View (FPV) Gear — **83**
- **Components of an FPV system** — **83**
 - The Camera — 84
 - CCD versus CMOS — 84
 - Onscreen display (OSD) — 86
 - The transmitter and receiver — 86
 - Video monitors — 87
- **Some general guidelines** — **88**
 - Rules for flying — 88
 - Priority 1 – safety for the public — 88
 - Priority 2 – follow the law — 89
 - Priority 3 – safety for your aircraft and camera — 90
 - Priority 4 – get the shot — 90
- **Summary** — **90**

Chapter 7: Camera Flying Techniques — **91**
- **Executing camera moves** — **91**
 - Crane shots — 91
 - Dolly shots — 93
 - Fly-through shots — 94
 - Orbit-by shots — 95
 - The 360 orbit — 96
- **Indoor flying considerations** — **97**
- **Experiencing an autonomous flight** — **98**
- **Summary** — **100**

Chapter 8: Post Processing — **101**

Cutting your clips into segments	101
Using Adobe's Warp Stabilizer	103
Summary	105
Index	**107**

Preface

Let's face it ... multicopters are cool. If they weren't, you wouldn't have an interest in this book! They look like something straight out of science fiction, with their exposed wires, spinning blades, and mean profile. But, how do you sift through the plethora of information and opinions on the Web and at your local hobby shop? And what the heck is a gimbal?

This book is an introduction to the world of multicopters, presented in a casual and conversational way. Although examples, opinions, and advice are given in these pages ... the principles and information you'll need to make your own decisions are given to you in a practical way. Even the most experienced multicopter pilots will find something in these pages new to them.

What this book covers

Chapter 1, *What is a Multicopter?*, provides a very basic overview of how multicopters fly and what components they use.

Chapter 2, *Buying a Turnkey System*, gives you an overview of the systems out there, the pitfalls of choosing cheap versus reliable, and where to get good information about turnkey systems.

Chapter 3, *Choosing Your Components*, provides an in-depth look at the components of a multicopter system and the calculations needed to choose the right parts.

Chapter 4, *Assembling Your Drone*, is a brief walkthrough of the wiring diagram and best practices for building a multicopter.

Chapter 5, *Flying Your Multicopter*, prepares you for the first flight of your multicopter, maidening, and practicing.

Preface

Chapter 6, *First Person View (FPV) Gear*, explains how to add an FPV system to your multicopter in order to fly it as if you were onboard.

Chapter 7, *Camera Flying Techniques*, discusses how to effectively use your new skills to get great camera shots and a stunning flying experience.

Chapter 8, *Post Processing*, explains how to stabilize and prepare clips for editing.

What you need for this book

For this book, you'll need a strong interest in flying a multicopter and a working knowledge of basic math. It helps to be mechanically minded. In the final chapter, we'll be using Adobe Premiere Pro CC 2014.

Who this book is for

This book is for experts and beginners to the multicopter world alike. It's tailored to those who aspire to eventually become professionals in shooting aerial imagery.

Conventions

In this book, you will find a number of styles of text that distinguish between different kinds of information. Here are some examples of these styles, and an explanation of their meaning.

Code words in text, database table names, folder names, filenames, file extensions, pathnames, dummy URLs, user input, and Twitter handles are shown as follows: "The value of `1.3` is a typical value."

New terms and **important words** are shown in bold. Words that you see on the screen, in menus or dialog boxes for example, appear in the text like this: "Clicking on the **Motor Test** button opens the motor test interface."

Reader feedback

Feedback from our readers is always welcome. Let us know what you think about this book—what you liked or may have disliked. Reader feedback is important for us to develop titles that you really get the most out of.

To send us general feedback, simply send an e-mail to feedback@packtpub.com, and mention the book title via the subject of your message.

If there is a topic that you have expertise in and you are interested in either writing or contributing to a book, see our author guide on www.packtpub.com/authors.

Customer support

Now that you are the proud owner of a Packt book, we have a number of things to help you to get the most from your purchase.

Downloading the color images

We also provide you with a PDF file that has color images of the screenshots/diagrams used in this book. The color images will help you better understand the changes in the output. You can download this file from the following link: https://www.packtpub.com/sites/default/files/downloads/5438OT_ColoredImages.

Errata

Although we have taken every care to ensure the accuracy of our content, mistakes do happen. If you find a mistake in one of our books—maybe a mistake in the text or the code—we would be grateful if you would report this to us. By doing so, you can save other readers from frustration and help us improve subsequent versions of this book. If you find any errata, please report them by visiting http://www.packtpub.com/submit-errata, selecting your book, clicking on the **errata submission form** link, and entering the details of your errata. Once your errata are verified, your submission will be accepted and the errata will be uploaded on our website, or added to any list of existing errata, under the Errata section of that title. Any existing errata can be viewed by selecting your title from http://www.packtpub.com/support.

Piracy

Piracy of copyright material on the Internet is an ongoing problem across all media. At Packt, we take the protection of our copyright and licenses very seriously. If you come across any illegal copies of our works, in any form, on the Internet, please provide us with the location address or website name immediately so that we can pursue a remedy.

Please contact us at `copyright@packtpub.com` with a link to the suspected pirated material.

We appreciate your help in protecting our authors, and our ability to bring you valuable content.

Questions

You can contact us at `questions@packtpub.com` if you are having a problem with any aspect of the book, and we will do our best to address it.

1
What is a Multicopter?

In the simplest terms, a multicopter uses multiple propellers (rather than a single rotor blade such as on a traditional helicopter) to provide lift. Also, there is no tail rotor (used to provide yaw control and counter the torque put out by driving the main rotor on a helicopter). Multicopters come in many configurations. There are bicopters (two rotors such as on CH-46 helicopters), tricopters, quadrocopters, and so on. In the following image, you can see an example of a quadrocopter as well as two configurations of hexacopters (six rotors):

Let's also think of what a multicopter isn't. We've all heard that dreaded term ... *drones*. A multicopter isn't really a drone in the true sense. Rather, it's defined by the U.S.'s Federal Aviation Administration as an **Unmanned Aerial System (UAS)**. The term UAS covers a wide array of aircraft, from drones to your average hobby radio-controlled airplanes. Most multicopters are piloted in the **line of sight (LOS)**, just as any radio-controlled airplane. This variety is not considered a drone. Technically, a drone both flies outside LOS and has the capability of autonomous flight (autopilot).

With specialized equipment, you can fly a multicopter using a **first person view (FPV)** camera system, telemetry, and so on, and turn your multicopter into a fully autonomous drone. Therefore, some drones are multicopters, but not every multicopter is a drone.

Most multicopter pilots, however, shy away from the term drone. This is because the term drone evokes images of aerial assassinations using missiles and guns mounted on the aircraft. For instance, in a 2013 article in the Santa Rosa Press Democrat about multicopters, a Santa Rosa police officer was quoted as mentioning "fly-by gang shootings" as crimes just around the corner. Once you know how a multicopter flies, the idea of mounting a weapon system onto a multicopter is physically laughable and ludicrous. Mounting a firearm to a drone provides such a counterforce (kick) that the mental image of the result conjures Wile E. Coyote chasing the Road Runner. The multicopter flying backwards as the bullet stays in one place. Comical indeed!

A multicopter's primary function is for videography, cinematography, and photography. So, what's the difference between a multicopter and a drone? The answer is the guidance system and how you choose to use it.

Still confused? Don't worry, that's what this book is for. Let's dive right in ...

How do multicopters fly?

Multicopters fly by utilizing two basic principles: lift and torque. Multicopters are truly a great exercise in Newtonian Physics (every action has an equal and opposite reaction). In a traditional helicopter, the main rotor spins in one direction. To keep the body from spinning the other way (remember, every action has an equal and opposite reaction), a tail rotor is implemented in order to put a constant pressure on the tail to keep the body stable. A multicopter uses counter-rotating propellers to keep the body stable while the propellers turn.

The axes of rotation on an aircraft are called pitch, yaw, and roll. **Pitch** is simply pointing the nose of the aircraft up or down. **Yaw** is turning the aircraft to the left or right. **Roll** is turning the aircraft such that the sides go up and down (rolling to the left would make an airplane's left wing dip down).

A multicopter's yaw control

A multicopter uses these principles of pitch, yaw, and roll to its advantage. In the following diagram, you can see that propellers **1** and **3** move in one direction, while **2** and **4** move in the other. By slowing down **1** and **3** while speeding up **2** and **4**, you can make the multicopter yaw to the left. The torque of **2** and **4** spinning to the right makes the body spin to the left. Conversely, by slowing down **2** and **4** while speeding up **1** and **3**, the multicopter yaws to the right.

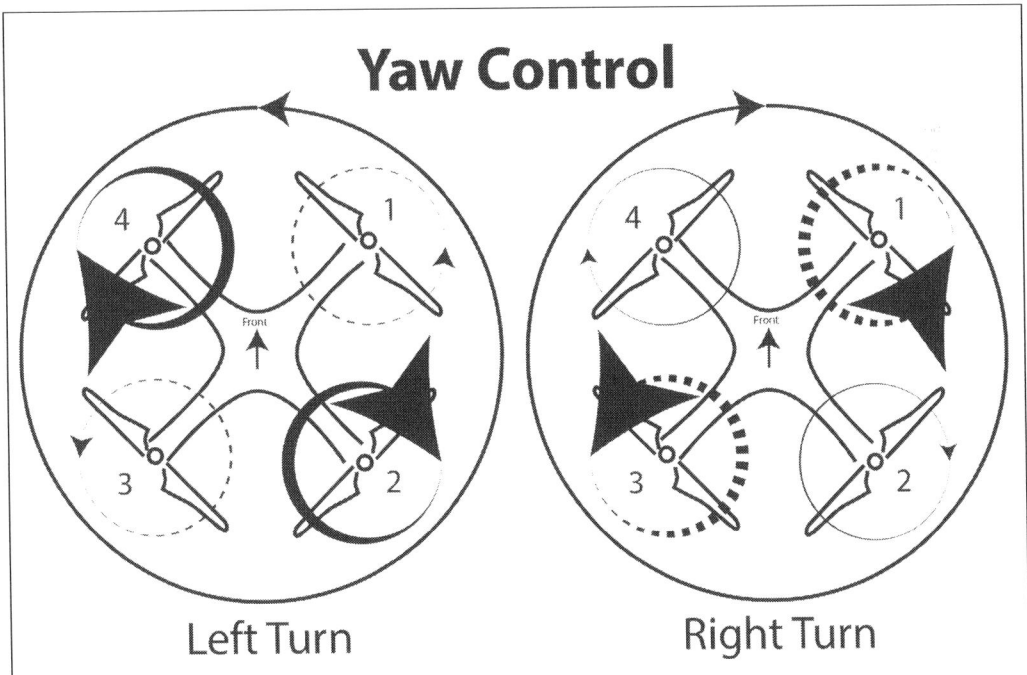

The principles of multicopter lift

So, that takes care of yaw control. Now, how does a multicopter move up and down? Here, it's similar to a traditional helicopter. A simple increase in the throttle of all the motors together pushes more air down. By pushing air down, the multicopter rises because the volume of the air flowing down from the rotors has greater thrust than the multicopter's weight. Decrease the speed of the propellers, and the thrust may stay the same as the multicopter's weight (providing a hover) or may dip down below the weight of the multicopter, causing a descent. The following image shows a good example of a multicopter holding a hover:

How a multicopter moves

This is truly where a multicopter shines. A traditional helicopter is not symmetrical from every angle; therefore, as it flies sideways, the tail wants to swing to the rear and the nose points in the direction of the flight. The wind pushes the tail just like a weather vane. The pilot must counter this by yawing in the same direction of flight, or stability can become an issue. Multicopters are symmetrical from every direction. Therefore, moving sideways has the same feel as forward flight to the pilot.

Just like a traditional helicopter, a multicopter moves forward/backward and from side to side by tilting. Tilting the multicopter changes the direction of the thrust provided by the rotors. For example, by dipping the nose and raising the tail, the direction in which the air flow is pushed is not only down, but also to the rear of the multicopter. If every action has an equal and opposite reaction, pushing air to the rear of the multicopter pushes the multicopter forward. To make one side dip, the speed of the propellers is reduced, and to raise another side, the speed of the motors on that side is increased. The following diagram shows how directional flight is achieved:

It all seems rather simple, right? Increasing and decreasing the speed of each motor provides movement in any direction. The direction is only dependent on the combination of motors that are increased or decreased. There are less moving parts in a multicopter than in a traditional helicopter. The movement in one direction has the same feel as in any direction because the aerodynamics are symmetrical.

So, why do traditional helicopters exist at all? The reason is that the electronics and components of a multicopter have only recently (after the year 2000) begun to be practical and small enough to really make them work. Imagine controlling the speed of each motor independently to control your multicopter by feel. It would be impossible without the help of some very sophisticated electronics. This brings us to the next section.

What's in a multicopter?

We'll go more in depth on each of these parts in *Chapter 3, Choosing Your Components*. For now, let's get acquainted with what makes up a multicopter.

The airframe

Multicopter frames come in all shapes and sizes, from basic quadrocopters to eight-bladed monster octocopters. They are available for a wide variety of prices too. Sometimes, large frames that cost more are really better. However, this is rare indeed. We will give you more details later, but note that before you choose any components, you should have your purpose in mind. Bigger is not always better, and smaller can't carry much weight. In the following image, you can see a hexacopter frame that retails for under 100 USD and can carry quite a bit of weight. Of course, the components required to fly such a beast can cost you well over 3000 USD (not including the batteries).

Motors and propellers

Motors and propellers are the main propulsion systems for your multicopter. It's truly where the rubber meets the road. These components are, by far, under the greatest strain of any component of your multicopter. Every ounce of weight that your multicopter carries rests on the blades of the propellers. So, as you can tell, strength is a prerequisite.

The bigger are the blades, the more lift there is. However, the bigger the blades, the more is the leverage placed upon the hub of the blades and more strain is exerted. Skimp on the blades and they'll snap, and your whole investment comes crashing to the ground.

Also, the bigger the blade, the stronger the motor must be in order to counteract the torque required to turn the blade. It might seem like the motor doesn't truly have to deal with a lot of resistance. But that's just not true. If a propeller is moving enough air to lift a couple-dozen pounds into the air, there is a lot of wind resistance that the motor must counteract. Faster motors are weaker. It's a giant balancing act to figure out how to get the right blades, motors, and so on, to lift your payload for the longest time possible.

The following image shows carbon fiber blades attached to motors that spin at 480 RPM per volt (KV):

The electronic speed control

The **electronic speed control** (**ESC**) is a marvelous invention. This truly makes flying multicopters possible. Electric motors require more voltage to start spinning than to keep spinning at their lowest speed. Also, as you apply more voltage, they don't necessarily speed up on an even curve. The ESC spikes the voltage to start the motor and eases it back to keep them spinning at a low speed on a low throttle. Also, as you apply more throttle input, the ESC accelerates the motor evenly. Furthermore, most ESCs can be programmed to any curve you like. A real tech head can have a field day just programming ESCs. Don't let that scare you though ... most ESCs are preprogrammed with the necessary settings to get you going without ever needing to dive in.

ESCs are the pass-through from battery to motor. They must be carefully balanced with the motor to give enough power to the motor and not burn out. Putting an underpowered ESC in your multicopter can cause crashes ... or even fires. You must have an individual ESC for every motor. The following image shows all the six ESCs tied down to the hub of this multicopter:

Chapter 1

The guidance system (the brain)

Now this is where the real magic happens. To fly a multicopter, it literally takes tens-of-thousands of calculations per second to sense whether you're going up or down or whether you are moving, tilting, or rotating, all the while adjusting your motors to counteract these forces to keep your multicopter stable. There are several aspects to the guidance system.

Most guidance systems have the same set of sensors nowadays. The main difference from system to system is how fast the calculations are done and the algorithms that are used in the firmware. Yes … I said firmware. These are literally flying computers.

In the following image, you can see the three main components of the DJI WooKong-M guidance system (this system has been the industry standard for multicopters for several years, so we'll use it as an example):

The circular module in the given image is a dual-purpose antenna. It senses both the direction (using a compass) and the GPS location (by using a 6-12 satellite lock system). This provides extremely accurate positional data for the brain to do its work.

In the other section of the photo, you'll see two grey boxes. The one in the background is the sensor box. This includes a 3-axis accelerometer and gyros to determine the pitch, roll, and yaw movement several thousand times a second. Additionally, it contains a barometer to indicate altitude. The box in the foreground is the main brain that takes all this information and your control inputs (coming in on the left side from the radio receiver), compares that to the GPS and compass data to create an accurate impression of what the drone is doing (as well as what you wish it to do), and sends speed information to the ESCs (out on the right side), and in turn to the motors to move your drone properly and in a stable fashion. Like I said ... this is where the magic happens.

Furthermore, there are more add-ons that you can get to interface with your guidance system. Camera gimbals can hook in the WooKong-M (and most other systems), and as the multicopter tilts to move, the camera can actually stay level. Also, **onscreen displays (OSD)** can be hooked in for your camera transmitter (allowing you to see all the telemetry, including battery life, attitude (orientation), height, and so on, on a viewing monitor while seeing what your camera sees). The following image shows the autonomous flight add-on. This unit communicates with the airborne multicopter from the ground using an iPad. You can actually click on a Google Earth map ... and the multicopter will fly there. Or, you can even draw out preprogrammed flight paths. These add-ons are what truly transform a multicopter into a drone.

Camera gimbals and transmitters

The term **camera gimbal** is a short way of saying, "a fancy device that keeps the camera leveled and reduces vibration no matter what the multicopter does within reason." So yeah ... camera gimbal is much shorter. Generally, these systems hook in to your guidance system and are tuned by the pilot (you) to work properly. Gimbals (good ones at least) are not cheap; the more weight that you want to carry and the more movement you want makes the price go up exponentially. The gimbal in the following image is capable of carrying a DSLR camera. It's made by Photoship One, and a new one retails for around 800 USD.

Furthermore, it's important to have a good transmitter. It's unheard of for any videographer to blindly shoot a video in a general direction while hoping to capture what he/she wants in a great way. It's unheard of because it's ludicrous, and the first sign that you've hired the wrong pilot. Transmitter/receiver systems are generally not all that expensive, and you can expect it to be one of the smallest investments you'll make. Be careful though. These can drain power rapidly if you get the wrong one.

Radio systems

Your radio is the primary interface between a human and a machine. It's important to get a good one that feels right for you. The buttons should be easy to find, and it should (above all) be reliable. FM transmitters are a way of the past. Futaba, with their FASST, and Spektrum/JR (with DSMx) are the waves of the present and future. No longer do you need to worry about competing transmitters, calling out a channel, or severe fading. The new generation of transmitters/receivers are digitally paired, and have LOS ranges in terms of miles. The following is an image of the Spektrum DX7s transmitter and the AR-8000 receiver with a satellite:

Summary

In this chapter, we learned how multicopters fly and got a basic overview of the components of a multicopter. Furthermore, we learned the functions of each of these components. In the next chapter, we'll learn about turnkey multicopters. We'll see how manufacturers of these components have put systems together and tuned them for your use. We'll also learn about the most (and least) trusted brands and a bit about where turnkey multicopters are headed.

2
Buying a Turnkey System

Now, you know a bit about how a multicopter flies and what the parts basically do. But let's face it; building a multicopter from scratch just isn't for the faint of heart, and frankly, it can be a bit of a learning experience. You might wish to choose a system that comes prebuilt, pre-tuned, and (for the most part) hassle-free. In this chapter, we're going to cover some of the turnkey systems out there and what to look for (and what to avoid).

Why choose a turnkey system?

Turnkey systems are usually more expensive, they usually take a while to arrive, and there's still a shakedown period once you get them. So, why choose one? Because no matter how much of a tech genius you might be … you are not a team of engineers, software developers, or quality assurance engineers making sure your design works properly and reliably.

Let me share a brief anecdote. Although I've been developing and shooting videos professionally with multicopters for over a decade, there have been a lot of mishaps with custom aircraft. My shins are scarred from blade strikes; I've spent tens-of-thousands of dollars in crashed aircraft due to everything from engine failures to fly-aways. And I'm what you'd consider an *expert* in this field.

Building a reliable multicopter can be far less expensive if you make one that works properly out of the box. It can be a disaster (financially and otherwise) if it doesn't. It can't be rushed and you can't take shortcuts, and testing, tweaking, and testing again isn't just necessary; it can be fatal to you or bystanders if you don't take these steps.

For these reasons, choosing a system that has gone through a ton of testing and research by teams of people who are seeking to keep a good market name is highly appealing. However, these waters aren't without their hazards and murk. Fly-by-night companies selling knockoffs, start-ups running out of garages, and the temptation of saving a few thousand dollars on something that outwardly looks just like the extremely expensive high-end multicopters are just some of the problems you might encounter with turnkey systems. Even the most reputable companies can make death machines at times.

Scared yet? Good. Multicopters can be dangerous, and it's important to respect this aspect of the aircraft. That being said, let's take a closer look at navigating these choppy seas …

If someone is selling it, it probably works … right?

Wrong! There are literally thousands of multicopters out on the market now. Out of all of these, there are maybe two or three that you can use reasonably safely and reliably. Remember … these aircraft have the glide profile of a brick. Furthermore, they're flying food processors (I've also heard the term "lawnmowers" used). They could (quite literally) kill someone if something goes wrong. Minimizing these risks starts with a reliable multicopter and ends with a very responsible and safety-conscious pilot.

Believe it or not, these aircraft are surprisingly simple to fly. For this reason, there is an illusion of simplicity about them. Make no mistake … they are extremely advanced and complex aircraft, requiring a very low tolerance for mistakes in the stabilization computer and even less tolerance for mechanical mishaps. This illusion of simplicity has birthed many a business, started in a garage, of assembling multicopters with parts that *should* work together (if you believe the marketing by the manufacturers of said parts). Unfortunately, though, we live in the world of what is … not what should be. The result is a 14-24 pound death brick just waiting to fall out of the sky and flop into an unsuspecting bystander … props spinning like samurai swords.

In the following image, you can see some frames taken from a news story that swept the US in May, 2014, taken from a cell phone. In the image, you can see a drone shooting an event called the *Great Bull Run* in Virginia. The drone inexplicably lost control and flew into a crowd. This behavior has been dubbed as *The Flip of Death* by multicopter pilots. It's generally caused by descending through prop wash, and the guidance system gets confused and apparently gives up trying to fly the multicopter. Some guidance systems and airframes are more prone to this behavior than others.

So, how do you avoid being the next pilot to hang your head in shame after being broadcast across the country (and world) as the "death pilot"? You can't ... entirely. These things are just like any technology. They can fail. All you can do is minimize your risks with a reputable aircraft and by being a responsible pilot. This way, when (not if) you have a malfunction, the frequency is as rare as possible, and the aircraft is less likely to hurt someone or any property.

One of the ways to do this is to learn from the mistakes of others.

Where to look for reviews and advice you can trust

First off, don't even bother to look at magazines. You can't trust them. Sure, they'll tell you the bad and good. But the bad always sounds okay, and the good sounds downright miraculous. It's like listening to a political speech. This is because magazines make their money from advertisement. If they completely trash a horrible product, that company might decide to not advertise anymore. I know ... magazines charge per issue, so if they want to keep readers, they should tell the truth. Unfortunately, we don't live in the world of what *should* be. I won't get into the ins and outs of magazine reviews. Let's just say that I know of many a reviewer who have had their verbiage changed to cast a better light on the product they're reviewing than it deserves by the editors of magazines. Not all magazines are like this but sifting through which ones are can be even murkier than sifting through good multicopters and bad. It's better to just avoid magazine drone reviews altogether.

For cameras, and even drones ... sure, magazines are a great source to hear about the latest and greatest. Just don't trust them to tell you whether it's good or not. For this ... go to online communities.

Online communities – the new consumer reports

Online communities are awesome. They are truly the best wave of information flow in the modern age. Wikis don't hold a candle to them …. Why? Because ultimately, a Wiki is filtered by one topic admin for what they deem as accurate. Online forums are an entirely different beast. There, you can sit back and watch a debate about a product you're interested in unfold point by point. Communities are filled with people who want to do, have done, or are doing exactly what you are doing. People all over the world participate in online communities, and you can find an answer, ask a question, and get a response any time of the day or night (in minutes on a large enough forum).

Of course, you'll have to deal with trolls (people looking to just aggravate others by arguing with anything they have to say or even correcting their grammar). By the way, a grammar troll has been dubbed a "Groll" by some. But even trolls can be useful. Information is your greatest ally, and greatest weapon in the war that you're going to have to battle with marketing. I say this because it really is like a battle.

Companies market their products with lies of omissions, changing subjects, loss leaders, and many other strategies. And in this war, information is your gun. To quote Clarence from the movie *True Romance* (1993):

> *"If there's one thing this last week has taught me, it's better to have a gun and not need it than to need a gun and not have it."*

So ... it is better to have information and not need it than to need it and not have it. This principle is called Clarence's rule.

Similarly, trolls are useful because although some of the information they bring to light might appear useless, at some time in the future, it could become relevant to you in your battle through the minefield of marketing.

RCgroups.com – the largest of the communities

The very first place you should look when seeking advice about your multicopter choice is **RCgroups.com**. By far, it is the largest of the communities, and there isn't a professional multicopter pilot who is not on these boards. For that matter, you'll be hard-pressed to find an amateur without an RCG profile. If you run into me there, feel free to send me a "hello". My profile name is `taudronis`.

You'll find everything about anything on any RC aircraft on RCG (including a whole section devoted to multicopters). The moment a new product is announced, members rush to post the first thread about it. Manufacturers have customer service representatives on the site, and they will publicly answer your questions and even engage in conversations with the community. In some cases, I've even seen the community come to a member's defense when a customer service issue pops up. Things are not only discussed on RCgroups.com ... they get resolved.

If you go to no other community whatsoever ... make sure you go to `RCgroups.com`.

YouTube.com – your source for user reviews, warnings, and tests

Are you really interested in hearing what someone like me thinks of a drone? Maybe; but wouldn't you rather hear what someone like you thinks? Doing a simple keyword search for whatever multicopter you're curious about on YouTube can get some interesting results. I've changed my mind about many a purchase after seeing reviews on YouTube. From general RC aircraft reviews (such as my **TestPilotRC** channel, `https://www.youtube.com/user/testpilotrc`) to multicopter specific channels, YouTube is a repository of loads of multicopter knowledge. The key is to look for trends on YouTube ... not the outlier reviews.

Time for another anecdote! I was recently thinking about picking up a DJI Spreading Wings S800. It is on clearance now (at the time I'm writing this), and DJI is one brand I usually trust. So, I went onto YouTube and looked up `DJI S800`. I was shocked by what I found. I saw a plethora of dissatisfied customers complaining about everything from Flip of Death issues to over 11 mm of flex on the motor spars at full throttle. Just so you know, flexing spars (arms) on your multicopter can cause serious problems, from harmonic oscillations to overcorrection on the part of your stabilization computer. I decided I would avoid the S800 like the plague.

Other useful YouTube searches would include `[your product] problems`, `[your product] review`, or `[your product] fix`.

Other sites that can be used

Of course, we could go on all day giving impressions of different sites that can be used to gain information about your product of interest. The two sites mentioned in the previous sections are the biggies. Google (of course) is always useful; `DIYdrones.com` is also a great site. But really, you should be able to get anything you need from YouTube and RCG.

What to expect for your budget...

This greatly depends on what your final purpose is. As technology gets better, cameras get smaller and capture more stunning detail with less bulk.

Setting realistic expectations

Depending on how old you are, you might remember Betacam SP cameras: the last of the great SD analog cameras. They could cost anywhere from 50,000 USD to 150,000 USD and up. Yes ... this much for one analog SD (720x486) camera that needed a muscle-bound cameraman to carry it. Compare this to the modern DSLR cameras, and you realize that the gargantuan relic is nothing better than a doorstop today. The lesson: bigger is *not* always better.

If your goal is to carry a giant cinematic camera (such as a RED Scarlet), let me stop you right there. Even the DJI Spreading Wings S1000 (which, according to reports, has overcome all of the problems the S800 had)—a gargantuan octocopter that will run you upwards of 6,500 USD (without a radio or most of the other necessary accessories)—doesn't work well with that kind of payload. Oh, it *could* lift it. But just because something *can* do something, that doesn't mean it *should*.

Of course, shooting videos at a stunning 6K resolution would be great. But that's a lot of liability up there. Also, it's a lot of variables: lens weight, leverage (from the length of the lens), battery weight for the camera, matte box, downdraft deflection (from the matte box), and the list goes on … and on.

In this case, bigger is definitely *not* optimal. The GoPro Hero 4 is rumored to shoot at 4K with a stunning 30 frames per second. It's lighter, cheaper (so not as much of a worry on crashes), and the list of its advantages (for multicopter applications) goes on … and on.

Other cameras (such as the Sony NEX, Canon 5D Mk III, and so on) also shoot with stunning quality and have great lenses. Any way it goes, you should really have a camera in mind that you want to mount on your drone ahead of time.

Brands you can trust

In reality, this changes all the time. Technology is constantly evolving, and new companies come and go. But through it all, there have been two companies that have been producing stunning multicopter systems. Even the pioneer of the multicopter shooting platform (DraganFlyer) has fallen to the back of the pack. The two companies that have stood the test of time are **DJI** and **MikroKopter**.

I know I'm going to get some heat for that statement, but it's true. These systems are truly turnkey. Out of the box and ready to go, just snap it together, perform a few dozen flights of shakedown, and go earn some cash flying (provided you already know how to fly). However, what drone do you get for the camera you've chosen?

For GoPro shooting

This one's simple. Nothing but nothing compares to the DJI Phantom series. I've actually shelved my giant drone as of late because of the ease and reliability of the Phantom 2. Combined with its H3-2D or H3-3D gimbal, the mini iOSD (for onscreen telemetry), and an Immersion RC FPV (the video transmitter and monitor) system, this system will knock your socks off without breaking the bank. The following image shows you my Phantom 2 equipped with the H3-2D, GoPro Hero3+ (black), and Immersion RC cloverleaf transmitter (with DJI iOSD mini):

Photo by John Nelson

With a GoPro Hero3+ (black), a couple of spare batteries, and a hard case, you're looking at around 2,000 USD to get some amazing aerial shots. It's extremely stable, with zero shutter roll (jello effect), and will even fly indoors extremely well. I've gotten some great shots flying it over a ridge, down to a house, and then into the house through a sliding door. These shots looked as though the drone was riding on invisible rails and turned out breathtaking. (Some examples of my shots with the Phantom 2 are available at https://www.youtube.com/watch?v=2rt8daAgrjo.)

The Phantom 2 is even prewired for video transmitters and the H3 series Zenmuse gimbals. It will also charge your GoPro while you fly!

This multicopter is truly a masterpiece and a must-have if you're planning on shooting with a GoPro.

Bigger cameras

Bigger cameras (such as DSLRs) are fantastic. And now, with the 5D Mk III and cameras of the sort, real-time autofocus makes mounting them on a faraway drone more practical. Although manual focus is always preferable, don't have any illusions about mounting a remote follow focus on a drone. Space and weight come at a premium when trying to fly, and this just isn't a practical use of said resources. So, whatever camera you're mounting ... autofocus is a prerequisite.

There are really only two platforms to choose from in this price range: the MicroKopter MK Okto series and the DJI Spreading Wings S1000 with Zenmuse 15. Either way, you're looking to spend between 7,000 USD and 10,000 USD (depending on the transmitter, FPV system, and so on).

These really are the two big boys on the block with the best reputations. Most professional rigs use either of their control systems, and these platforms are tuned to work with all of the parts they use. Of course, DJI's reputation is slightly injured by the S800 problems, and the S1000 is still very new to market. However, DJI does have a good history of reliable machines otherwise. MikroKopter is a German company with an excellent reputation in the television and film industry in Europe. The following image shows you the MikroKopter (left) and the DJI S1000 (right):

Summary

In this chapter, we have explored the reasons to use turnkey systems. We also learned that there are pitfalls in choosing less expensive brands. Furthermore, we explored that some of these pitfalls are dire consequences indeed. It boils down to a choice: do you save a few bucks in the beginning with a fly-by-night manufacturer and risk getting sued by a crash victim (best case) or killing someone (worst case); or do you shell out more cash and get something reliable? Is there really a choice when choosing a turnkey system?

There is another option in saving some cash up front: building your own multicopter. In the next chapter, we'll discuss how to build your own multicopter. This will be a very in-depth process and will educate you significantly on the math involved and just how to tune a proper machine.

3
Choosing Your Components

So, we've learned about how multicopters fly. We've learned about what's in multicopters. We've even learned a thing or two about safety concerns. Now, let's dive into the process of choosing components for your multicopter. There are a ton of choices, permutations, and combinations available. In fact, there are so many choices out there that it's highly unlikely that two **do it yourself** (**DIY**) multicopters are configured alike.

It's very important to note before we start this chapter that this is just one example. This is only an example of the thought process involved. This configuration may not be right for your particular needs, but the thought process applies to any multicopter you may build. With all these disclaimers in mind … let's get started!

What kind of drone should I build?

It sounds obvious, but believe it or not, a lot of people venture into a project like this with one thing in mind: "big!". This is completely the wrong approach to building a multicopter. Big is expensive, big is also less stable, and moreover, when something goes wrong, big causes more damage and is harder to repair. Ask yourself what your purpose is. Is it for photography? Videography? Fun and hobby interest? What will it carry? The example in this book is based on a standard videography drone that carries a camera between 2 and 7 pounds in weight. This covers everything from a camcorder to a small DSLR camera.

How many rotors should it have?

There are many configurations, but three of these rotor counts are the most common: four, six, and eight (quad, hexa, and octo-copters). The knee-jerk response of most people is again "big". It's about balancing stability and battery life. Although eight rotors do offer more stability, it also decreases flight time because it increases the strain on batteries. In fact, the number of rotors in relation to flight time is exponential and not linear. Having a big platform is completely useless if the batteries only last two or three minutes.

Redundancy versus stability

Once you get into hexacopter and octocopters, there are two basic configurations of the rotors: redundant and independent. In an **independent** (or **flat**) configuration, the rotors are arranged in a circular pattern, equidistant from the center of the platform with each rotor (as you go around) turning in an opposite direction from the one before it. These look a lot like a pie with many slices. In a **redundant** configuration, the number of spars (poles from the center of the platform) is cut in half, and each has a rotor on the top as well as underneath. Usually, all the rotors on the top spin in one direction, and all rotors at the bottom spin in the opposite direction. The following image shows a redundant hexacopter (left) and an independent hexacopter (right):

The advantage of redundancy is apparent. If a rotor should break or fail, the motor underneath it can spin up to keep the craft in the air. However, with less points of lift, stress on the airframe is greater, and stability is not quite as good. If you use the right guidance system, a flat configuration can overcome a failed rotor as well. For this reason (and for battery efficiency), we're going with a **flat-six** (independent hexacopter) configuration over the redundant, or octocopter configurations.

Chapter 3

The calculations you'll need

There is an exorbitant amount of math involved in calculating just how you're going to make your multicopter fly. An entire book can be written on these calculations alone. However, the work has been done for you! There is a calculator available online at eCalc (`http://www.ecalc.ch/xcoptercalc.php?ecalc&lang=en`) to calculate how well your multicopter will function and for how long, based on the components you choose. The following screenshot shows the eCalc interface:

Overwhelmed? Don't be. That's why this chapter is so long. We're going to walk you through these choices step by step (as well as how to adjust choices based on the results).

[31]

Choosing your airframe

Although we've decided to go with a flat-six airframe, the exact airframe is yet to be decided. The materials, brand, and price can vary incredibly. Let's take a quick look at some specifications you should consider.

Carbon fiber versus aluminum

Carbon fiber looks cool, sounds even cooler, but what is it? It's exactly what it sounds like. It's basically a woven fabric of carbon strands encased in an epoxy resin. It's extremely easy to form, very strong, and very light. Carbon fiber is the material they make super cars, racing motorcycles, and yes, aircraft from. However, it's very expensive and can be brittle if it's compromised. It can also be welded using nothing more than a superglue-like substance known as C.A. glue (cyanoacrylate or *Superglue*).

Aluminum is also light and strong. However, it's bendable and more flexible. It's less expensive, readily available, and can make an effective airframe. It is also used in cars, racing motorcycles, and aircraft. It cannot be welded easily and requires very special equipment to form it and machine it. Also, aluminum can be easier to drill, while drilling carbon fiber can cause cracks and compromise the strength of the airframe.

What we care about in a DIY multicopter is strength, weight, and yes ... expense. There is nothing wrong with carbon fiber (in fact, in many ways, it is superior to aluminum), but we're going with an aluminum frame as our starting point.

We'll need a fairly large frame (to keep the large rotors, which we'll probably need, from hitting each other while rotating).

What we really want to look at is all the stress points on the airframe. If you really think about it, the motor mounts, and where each arm attaches to the hub of the airframe are the areas we need to examine carefully. A metal plate is a must for the motor mounts. If a carbon fiber motor mount is used, a metal backplate is a must. Many a multicopter has been lost because of screws popping right through the motor mounts. The following image shows a motor mount (left) where just such a thing happened. The fix (right) is to use a backplate when encountering carbon fiber motor mounts. This distributes the stress to the whole plate (rather than a small point the size of a screwhead). Washers are usually not enough.

Similarly, because we've decided to use an airframe with long arms, leverage must be taken into account on the points where the arms attach to the hub. It's very important to have a sturdy hub that cradles the spars in a way that distributes the stress as much as possible. If a spar is merely sandwiched between two plates with a couple of bolts holding it ... that may not be enough to hold the spars firmly. The following image shows a properly cradled spar:

Choosing Your Components

In the preceding image, you'll notice that the spars are cradled so that stress in any direction is distributed across a lot of surface area. Furthermore, you'll notice 45 degree angles in the cradles. As the cradle is tightened down, it cinches the aluminum spar and deforms it along these angles. This also prevents the spars from rolling.

Between this cradling and the aluminum motor mounts (predrilled for many motor types), we're going to use the **Turningy H.A.L. (Heavy Aerial Lift)** hexacopter frame. It carries a 775 mm motor span (plenty of room for up to 14-inch rotors) and has a protective cover for our electronics. Best of all, this frame retails for under 70 USD at `http://www.hobbyking.com/hobbyking/store/uh_viewitem.asp?idproduct=25698&aff=492101`.

Now that we've chosen our airframe, we know it weighs 983 grams (based on the specifications mentioned on the previous link). Let's plug this information into our calculator (refer to the following screenshot). You can see that we've set our copter to `6` rotors, our weight to `983` grams, and specified that this weight is a **without Drive** system (not including our motors, props, ESCs, or batteries).

General	Motor Cooling:	# of Rotors:	Model Weight			Field Elevation		Air Temperature		Pressure (QNH):	
	medium ▼	6	983	g	without Drive ▼	500	m ASL	25	°C	1013	hPa
			34.7	oz		1640	ft ASL	77	°F	29.91	inHg

You can leave all of the other entries alone. These specify the environment you'd be flying in. Air density can affect the efficiency of your rotors, and temperature can affect your motors. These default settings are at your typical temperature and elevation. Unless you're flying in the desert, high elevations, or in the cold, you can leave these alone. We're after what your typical performance will be.

Choosing your propellers

Let's skip down to the propellers. These will usually dictate what motors you choose, and the motors dictate the ESCs, and the ESCs and motors combined will determine your battery. So, let's take a look at the drive system in that order.

This is another *huge* point of stress. If you consider it, every bit of weight is supported by the props in the air. So, here it's very important to have strong props that cut the air well, with as little flex as possible, and are very light. Flex can produce bounce, which can actually produce harmonic vibration between the guidance system and the flexing of the props (sending your drone into uncontrolled tumbles).

Does one of the materials that we've already discussed sound strong, light, and very stiff? If you're thinking carbon fiber, you're right on the money. We're going to have a lot of weight here, so we'll go with pretty large props because they'll move a whole lot more air and carbon fiber because they're strong.

The larger the props, the stronger they need to be, and consequently the more powerful the motor, ESC, and battery. Before we start shopping around for parts, let's plug in stats and see what we come up with.

When we look at props, there are two stats we need to look at. These are diameter and pitch. The diameter is simple enough. It's just how big the props are. The pitch is another story. The pitch is how much of pitch the blade has. The tips of a propeller are more flat in relation to the rotation. In other words, they twist. Your typical blade would have something more like a 4.7-inch pitch at 10 inches. Why?

Believe it or not, these motors encounter a ton of resistance. The resistance comes from the wind, and a fully-pitched blade may sound nice, but believe it or not, propulsion is really more of a game of efficiency than raw power. It's all about the balance.

There's no doubt that we'll have to adjust our power system later, so for now let's start big. We'll go with a 14-inch propeller (because it's the biggest that can possibly fit on that frame without the props touching), with a typical (for that size) 8-inch pitch. The following screenshot shows these entries in our calculator:

You can see we've entered `14` for **Diameter** and `8` for **Pitch**. Our propellers will be typical two-blade props. Three- and four-blade props can provide more lift, but also have more resistance and consequently will kill our batteries faster. The **PConst** (or power constraint) indicates how much power is absorbed by the props. The value of `1.3` is a typical value. Each brand and size of prop may be slightly different, and unless the specific prop you choose has those statistics available ... leave this alone. A value of 1.0 is a *perfectly* efficient propeller. This is an unattainable value. The gear ratio is 1:1 because we're using a prop directly attached to a motor. If we were using a gear box, we'd change this value accordingly. Don't hit calculate yet. We don't have enough fields filled out.

It should be said that most likely these propellers will be too large. We'll probably have to go down to a 12- or even 11-inch propeller (or change our pitch) for maximum efficiency. However ... this is a good place to start. For now, let's move on to the motors.

Selecting your motor

Remembering that the props, motors, and ESCs must all be tuned to each other for optimum efficiency (and to minimize the risk of failures); now is the time to experiment. Before we get something in the air, experience a motor failure, start a forest fire, or worse yet, hurt an observer ... we can now play around with calculations and see what we get.

With motors and propellers, there is a universal truth: smaller propellers turn faster and larger ones turn slower. This is because of the risk of something similar to cavitation at the tips. With this in mind, we want the motors to turn as fast as possible without causing cavitation around our props. The term **cavitation** is usually used in terms of propellers in liquid. However, a similar principle applies in air. By spinning a prop, you create high-and low-pressure zones. If a prop spins too rapidly, the trailing blade may move through an area of low pressure and decrease its efficiency. Basically, this means moving through its own prop wash. This can be a huge problem for stability and lift. Furthermore, a cavitating prop can encounter shock waves and even shatter because of them. The tips could also break the sound barrier and cause a shockwave that shatters the blade.

We also need to consider leverage. As the blades are longer, the tips of the blades will be moving faster. This is both the reason for a twist in a propeller (to provide consistent lift across the whole blade) and the reason for rotating it slower (taking torque as a higher priority to speed and reduction of cavitation or sound barrier risk).

An electric motor's speed rating is in what's known as **KV**. Basically, this is **RPM** (or **revolutions per minute**) per volt of electricity supplied to the motor. A good motor for a larger blade would be between 350 and 600 KV. With a 14-inch prop, it's probably somewhere around 500 KV. In case you haven't noticed, this is where we do some guessing and see what happens in the calculations.

Another thing to take into account when choosing a motor is whether it should be brushed or brushless. Without getting too deep into the intricacies of motors, a brushed motor wears out (as there is friction involved in the use of brushes to time the polarity of the electromagnets driving the motor); whereas a brushless motor will last much longer and be far more efficient. It would be completely senseless to choose a brushed motor for a large multicopter, so we're going brushless no matter what.

We'll also need to consider the number of magnetic poles in the motor. A motor is a series of electromagnets and a series of traditional magnets. The electromagnets switch polarity between positive and negative to attract the traditional magnets and push them away in sequence. This is what makes the motor spin. If you followed the same principle on a line instead of a cylinder, you'd have a rail gun, or maglev train.

Between each magnetic pole is a dead zone. This zone is where the influence of the electromagnets isn't quite as strong as it is when it's close to the electromagnet. This is also where (during rotation) the influence of the previous pole is lost and the next pole is picked up. This can cause vibration, make the rotation of the motor slow, and speed up ever so slightly. We're using these to run a camera, so platform, stability, and vibration reduction is key.

The more magnetic poles we have, the smoother the rotation of the rotors. The following diagram shows a 4-pole versus 8-pole example of a brushless outrunner motor. This is where the outer can of the motor rotates while the inner electromagnets remain stationary.

![4-Pole Brushless Outrunner vs 8-Pole Brushless Outrunner diagram showing magnets, electromagnetic poles, attraction and repulsion arrows, and can rotation direction]

You can see how the overlapping fields of repulsion and attraction to the outer traditional magnets would produce a more steady thrust, less oscillation of the velocity of the motor, and less vibration overall. Basically, you can attain consistent power because of overlapping fields. The 8-pole motor is far superior to the 4-pole motor. Now imagine 20 or more poles. It would be like a surfer riding waves of electromagnetic fields. Huge, smooth waves. We'll be using 20-pole (or better) motors.

The final bit of consideration with a motor is the form factor. As we'll be using pretty powerful motors to turn our large propellers, they'll be big. We don't want a motor as tall as a beer can. Luckily, there is a solution for just such a problem. The Turnigy Multistar series of motors is among many that have more of a pancake form factor (wide, but short). Pancake motors are purpose-built for multicopters.

Choosing Your Components

Multistars have a good reputation for reliability, stability, and are cost-effective. Let's use these motors for this example (as the entire line is already built into the calculator). The following screenshot shows our selection of the Turnigy Multistar 4830 (480KV) motor:

We chose this motor because the KV rating is 480 (close to our estimated 500), can handle a large battery, and has 22 poles. You can see that once we selected the motor, all the other fields were filled in for us and grayed out (the option to change the values taken away). All of the specifications of this motor are already in the calculator, so we can move on. To learn more about this motor, you can check it out at http://www.hobbyking.com/hobbyking/store/uh_viewitem.asp?idproduct=26961&aff=492101.

The following image shows the motor we'll be using:

Now that we know what kind of motors we're using, we can choose the ESCs.

Selecting the ESCs

Your ESC choice is a crucial decision. These are really where most electronic failures happen. An improperly balanced ESC can not only figuratively burn up, but quite literally can catch on fire. I still remember when I first started using fixed-wing aircraft on weekends to keep my flying skills up (a great way of practicing line-of-sight flying without destroying your multicopter ... but we'll get into that in a later chapter).

I had an E-flite Spitfire Mk IV. It was a great plane, but I wanted it to go faster. So, I put a power 10 motor in it (a very powerful motor), and the spitfire caught fire in midair. It looked amazing ... like it had been shot down by the other warbird following it. But then it occurred to me, "Wait, it's heading for that field of dry grass, and I have no control!" Nothing bad happened ... fortunately. However, this is not always the case. Fire is never good in the air. It can be expensive, heartbreaking, and downright dangerous. Needless to say ... balancing your ESC against your motor and power supply is extremely important.

We want our amp rating on our ESCs to be slightly over the amp rating of the motor (22 amps constant and 31 amp burst by its specifications on the vendor website). We can also see that the Multistar 45 amp 2-6S (the *S* rating is the battery that we'll get into next) is what's recommended by the manufacturer.

Unfortunately, the Multistar ESCs are not in the calculator, and not every specification is on the manufacturer website. So, we'll have to do some estimating here. The following image shows the Multistar 45 amp 2-6S ESCs we'll be using. They're available at http://www.hobbyking.com/hobbyking/store/uh_viewitem.asp?idproduct=27777&aff=492101.

Choosing Your Components

First, let's get close. In the ESC section of the calculator, let's select **max 40A** (which means a 40-amp ESC). This fills in a lot of the fields for us. Then, switch back to **custom**. Note that you have to have the full version (0.99 USD) to customize this setting. Now, we can set our **cont. Current** and **max. Current** to 45 amps and our **Weight** to 63 grams. The following screenshot shows our filled-in ESC (controller) fields of our calculator:

Controller	Type:	cont. Curent:	max. Curent:	Resistance:	Weight:
	custom	45 A	45 A	0.006 Ohm	63 g
					2.2 oz

Another thing to consider is the **Battery Eliminator Circuit (BEC)**. Usually, an ESC has a BEC built in to power your radio receiver. However, the guidance system we're using in this example (we'll get to it later) will supply power to the radio, so the ESCs don't have a BEC. If the guidance system you choose has no power supplied to the radio receiver, you'll need a BEC for this. We'll be skipping BECs because most multicopter guidance systems worth their salt supply power to the receiver.

Now, there's one more item before we can calculate and adjust ... the battery.

Powering your multicopter – the battery

Again ... here is where you'll want to find the balance. Just because you have more voltage doesn't make your multicopter fly better. More voltage can also mean more weight.

When choosing a battery, there are a lot of chemical formulations available, from NiCd to LiPo. Without getting into all the ins and outs of battery chemicals, let me tell you this: the only choice for an aircraft is **LiPo (Lithium Polymer)**. This is because it gives you the best power and the lightest weight. LiPo batteries require special balancing chargers (that provide equal power to each cell of the battery), so make sure that you also get a LiPo-specific charger.

Also when choosing a battery, there are two numbers you should concern yourself with first: the S rating; and mAh rating.

The **S** rating of a battery simply means how many cells the battery has. Remember, a battery is not a single chunk of chemicals providing power. When you call that AA cell a battery, that's actually incorrect. The battery is the series of cells you have when you put two of those in your television remote. A battery is a collection of cells. Each LiPo cell is of 3.7 volts. So, a 2S battery is 7.4 volts, a 3S battery is 11.1 volts, and so on.

The **mAh (milliamp hour)** rating is really how long the battery will last. Each mAh represents 1 hour of battery power for each .001 amp (milliamp) of power drawn from it. So, as you can see, volts may not be the best use of weight. To get more time in the air, you'll want more mAh (or capacity) on your battery.

In all of my flying, I've used a lot of different brands of batteries. The best batteries I've found for the money are the Turnigy nano-tech batteries. They seem to be lighter and lasts me far more charges than other batteries I've tried with less **puffing**.

Puffing brings me to the final statistic (important, but the final consideration), that is, the **C** rating. Simply put, the **C** rating is how many times the mAh rating the battery can have drawn off of it safely. Overdrawing a LiPo battery can lead it to puff up ... literally, it expands. Overexpanding the battery can lead to an explosion of the battery and an extremely hot fire. If you ever have a battery puff on you, dispose of it properly and don't ever use or charge the battery again. A video of LiPo batteries puffing and burning can be found at `https://www.youtube.com/watch?v=zQheOtdCTjs`.

An example of a C rating is this: if a battery has 5000 mAh and a 1C rating, it can withstand 5 amps drawn from it. At 5000 mAh and a 30C rating, it can withstand 150 amps drawn from it safely. As we're using 6 x 45-amp ESCs, we should look at a battery that can withstand at least 270 amps of draw from it.

Let's start with two batteries, each at a 6S, 5000 mAh, and 45-90C.

These batteries (run in parallel) will give us 10,000 mAh of life and can discharge 450 amps (very comfortable for our 270 amp requirement). We'll probably need to respecify these later, but let's go for the gusto right now.

The following screenshot shows that we've picked the 5000mAh LiPo option with 6S, and 2P (parallel) in our calculator:

Battery Cell	Type (Cont./max. C) - charge state	Configuration	Cell Capacity	Total Capacity	Resistance	Voltage	C-Rate		Weight	
	LiPo 5000mAh - 45/60C ▼ normal ▼	6 S 2 P	5000 mAh	10000 mAh	0.0025 Ohm	3.7 V	45	C cont	140	g
							60	C max	4.9	oz

Ok, now let's hit **calculate** and move on to tweaking our specifications.

Tweaking your specifications for better results

If you've hit **calculate** already, you're probably thinking, "What went wrong?". In the following screenshot, we can see that our results show only 2.2 minutes of flight time and a whole lot of warnings!

Remarks:
- max. current over the limit of the speed controller. Choose a bigger esc.
- the prediction of the motor case temperature is critical (>80°C/175°F). Risk of overheat, please check!
- max. power over the limit of the motor. Please check the max. power limits defined by the manufacturer.

Battery		Motor @ Optimum Efficiency		Motor @ Maximum		Motor @ Hover		Total Drive	
Load:	27.52 C	Current:	26.79 A	Current:	45.67 A	Current:	6.32 A	Drive Weight:	3280 g
Voltage:	20.14 V	Voltage:	20.83 V	Voltage:	18.86 V	Voltage:	21.86 V		115.7 oz
Rated Voltage:	22.20 V	Revolutions*:	8804 rpm	Revolutions*:	7495 rpm	Throttle (linear):	26 %	All-up Weight:	4263 g
Flight Time:	2.2 min	electric Power:	558.1 W	electric Power:	911.0 W	electric Power:	138.2 W		150.4 oz
Mixed Flight Time:	3.3 min	mech. Power:	475.0 W	mech. Power:	737.8 W	mech. Power:	85.4 W	add. Payload:	8674 g
Hover Flight Time:	13.5 min	Efficiency:	85.1 %	Efficiency:	81.0 %	Efficiency:	61.8 %		306 oz
Weight:	1680 g			est. Temperature:	122 °C	est. Temperature:	55 °C	Current @ Hover:	37.90 A
	59.3 oz				252 °F		131 °F	P(in) @ Hover:	841.3 W
								P(out) @ Hover:	512.1 W
								Efficiency @ Hover:	60.9 %
								Current @ max:	275.22 A
								P(in) @ max:	6110.0 W
								P(out) @ max:	4427.0 W
								Efficiency @ max:	72.5 %

We've obviously overpowered our motors ... greatly. This is proof that bigger is not always better. We probably also have too much pitch on our props. The motor shows far too much draw in amps, and we're going to overheat and kill our motors and ESCs if we max out the throttle.

So, let's tinker. We still want our batteries to have as much life as possible because this means we stay in the air as long as possible. However, we may not need that many cells (S) in our batteries. Let's cut it in half (go down to 3S) and hit **calculate**. The following screenshot shows the results:

Ok, we're on the right track. We've gotten rid of the warnings, but our flight time is still only at 6.4 minutes. We still haven't added the weight of our camera, gimbal, or guidance system. Let's get that flight time up to at least 7 minutes by playing with the propellers.

Choosing Your Components

Let's shift the pitch of the props down from 8 inches to 7 inches and see what this gets us. The following screenshot shows us the results:

Cool! We've met our minimum of 7 minutes of flight time. The propellers are available at http://www.hobbyking.com/hobbyking/store/uh_viewitem.asp?idproduct=25696&aff=492101. For now, let's leave our stats alone and move on to the other components and see how that affects the results.

Delving into camera gimbals

The term **gimbal** refers to a point of rotation. The purpose of a camera gimbal is to counter the rotation of the multicopter as it tilts for flight by rotating the camera in the opposite direction on the gimbal. This effectively cancels the rotation of the multicopter and stabilizes the camera. The following image illustrates how the camera remains level even while the multicopter tilts:

Camera Gimbal Leveling

(Diagrams showing Roll and Pitch compensation by the camera gimbal, with the camera remaining Level while the multicopter tilts.)

So, that takes care of pitch and roll ... what about yaw? Yaw works a little differently. Some gimbals only stabilize on two axes (pitch and roll) so that **FPV (first person view)** flyers can tell which direction they are headed. Older 3-axis gimbals left the camera pointed in one yaw direction, no matter where the multicopter was facing. This could be problematic and confusing if it was flying using FPV. It would be like the cockpit of a helicopter pointed north while the rest of the aircraft faced south. Then, do you push the stick forward to go forward? Or would that make you go backward? Confusing.

Newer 3-axis gimbals (such as the H3-3D Zenmuse by DJI—made for GoPro cameras) dampen the effect of yaw. If the aircraft twitches (which can happen easily because of turbulence, or props speeding up or slowing down), it just dampens this effect. If you spin to the left suddenly, the gimbal delays the movement and ramps back up to meet up with the nose of the aircraft. It's kind of like a shock absorber for yaw. This can be very advantageous.

There are also two types of drive systems for the gimbals: servo and brushless. Servo gimbals are old school. They can have a lot of play unless you spend a boatload of money. They can be rough and slow to counteract the movement of the multicopter. Brushless gimbals keep the axis floating in a magnetic field. No play and no servo twitch. Brushless are far superior. The DJI Zenmuse series are fantastic brushless gimbals, but not the only gimbals on the market.

There is a problem with brushless gimbals though. You'll have a hard time finding one at a reasonable cost that can handle a larger camera. Even the DJI Zenmuse Z15 (at more than 3,000 USD) is made for smaller DSLRs (such as the Sony NEX-7). Down at the GoPro level, there are more options of similar quality ranging from 300-700 USD. So, although brushless is superior, our goal here is to save some cash.

If you're going with a servo gimbal, there is really only one choice. Photoship One has a great multicopter gimbal for full-size DSLRs, and you can get it (with all the bells and whistles offered) for under 500 USD. This gimbal is called the mkTR Professional and is available at `http://photoshipone.com/shop/index.php?main_page=product_info&cPath=4_7&products_id=236`. If you decide on this gimbal, make sure that you get the second roll servo and the gear drive version (this will significantly reduce the play in the gimbal). The following image shows the mkTR gimbal. Notice that it also comes with a complete set of landing gear designed just for the gimbal.

How does the gimbal know when to tilt and roll? Brushless gimbals require their own controller board. So, if you decide to go with this, make sure that the product description specifies that it comes with such a board. If not, you could be in for some unexpected expenses. A servo gimbal will usually plug right into your guidance system. Your guidance system is constantly aware of what your platform is doing and is making adjustments to keep your platform stable. As it adjusts, it can send this information directly to the servos without the need for an intermediary board. This also helps cut down on the latency between a platform move and a gimbal move. This brings us to the next item in our multicopter: the guidance system.

Before we move on though, let's add the weight of our camera and gimbal to our calculations. It weighs 480 grams. This brings our airframe weight from 983 grams to 1463 grams. We'll use a Canon T3i as our DSLR camera, and its weight is 583 grams, and the 50 mm lens prime we'll use is 545 grams. This brings our total weight of the airframe up to 2591 grams ... whoa! The following screenshot shows what has happened to our calculations:

Uh-oh! We've kicked out a warning. We're going to need every ounce of power just to hover. That means we'll never even take off. No worries though, we'll circle back after we figure the guidance system and radio and tweak the numbers some more. For now, on to the guidance system.

The multicopter brain – the guidance system

All guidance systems work on the same principle. They take in a boatload of positional data, compare the data points, and estimate what the multicopter is doing. Keep this in mind: the guidance system has to guess. The difference between systems is how well they guess and how quickly. They all use the same types of sensors, and the difference between the sensors is their accuracy and speed. These are what you need to consider in a guidance system: accuracy and speed. If a guidance system guesses wrong, you could have a Flip of Death or a fly-away on your hands. First, let's take a look at the types of sensors.

Multicopter guidance system sensor types

Multicopters use a variety of sensors to tell where they are and what they are currently doing. They sample this data anywhere from hundreds to tens of thousands of times a second. Let's take a look at them one by one.

Global Positioning System

Global Positioning System (GPS) is a modern-day wonder that most of us take for granted. GPS uses satellites that orbit around the planet and their clocks to calculate the time differential between the satellite and the GPS receiver. Once you can tell the time differential, you get the time it took the signal to go from a GPS satellite to the receiver and consequently the distance from the satellite to your receiver. Once you calculate the distance from multiple satellites, you can plot a radius from those satellites. Where they meet, that is where your receiver must be. The following diagram shows how this principle (signal triangulation) works:

Signal Triangulation

2 Satellite Lock — Signal Radius

3 Satellite Lock — Signal Radius

★ = Possible Locations

You can also see that in this example, three satellites are far more accurate than two. This is only represented in 2-dimensional space. In real 3-dimensional space, you'd need at least six satellites to maintain a fairly accurate lock. Even so, as signals are moving at the speed of light (299,792,458 meters/second), even calculating the latency to the nanosecond gives you a range of distance ... not an actual distance.

So, more satellites mean a more accurate guess as to the actual location. Going from 6 to 12 satellites on a lock can reduce the accuracy margin from several feet to inches. Needless to say that the more satellites your GPS receiver is capable of locking on to, and the faster it can sample the signal, the more accurate this GPS position will be.

Before we move on from GPS, let's get into one more fun fact. This will show you just how amazing GPS is. Gravity affects time. This is called *gravitational time dilation*. The closer you are to a gravitational source (say, Earth), the more slowly time passes. What?!

Yes, you read correctly. Time passes more slowly here on the surface of the earth than it does in orbit. Remember, we're dealing with nanosecond measurements of the time it takes a signal to reach a receiver. The difference is ever so slight, but enough to throw off all of the GPS data if dilation isn't accounted for. Due to this, the clocks on the GPS satellites are constantly corrected for this time dilation effect. This principle is why scientists believe that if you could withstand being crushed by the gravity in a black hole, and eventually escape ... you'd travel forward in time. In essence, when you use GPS ... you're using a time machine. Mind blown!

The compass

The oldest and most tried and true form of navigation is being able to tell which direction you're facing using a compass. No, there is not a little floating magnetic needle in your compass sensor. There is a sensor that measures the Earth's magnetic field. The sensor measures electric current in relation to this magnetic field. This is called the *Hall effect*.

Every time you fly your multicopter, the compass should be calibrated first. Some guidance systems store the calibration from the last use in the firmware upon calibration. However, as the Earth's magnetic field varies, oscillates, and changes slightly from point to point, and from day to day on the Earth's surface, unless you're taking off from the same spot every time in exactly the same magnetic conditions ... you should always calibrate your compass before flight. It's always safest to make this a part of your preflight tasks every time you power on your multicopter just in case. Not calibrating your compass can be fatal for your multicopter.

Again, this is all about accuracy. A sure sign that your compass is not calibrated, or not working properly is called **toilet bowling**. A funny name for sure, but it can lead to unstable footage, or even a crash. It's essentially where you are trying to hover, and while doing the minor corrections that a multicopter does in order to fly, it thinks it's pointed in a slightly different direction than it really is pointed. So, instead of moving northwards, it moves slightly to the east, then to correct and move slightly towards the west, it moves a little to the south. This makes the multicopter swirl as if it were getting flushed down a toilet. If you don't correct this, you may as well have flushed your investment down that proverbial toilet (because you're destined for unusable footage, or even a crash).

Another sign of an inaccurate compass is **dog running**. If you've ever seen a dog run, you'll notice they move a little sideways to keep their feet from hitting each other. Similarly, if you push forward on the stick, your multicopter flies north, but it needs to point the camera a little east or west to do it. Dog running is where your multicopter doesn't align true to the direction of flight.

So, a fast-sampling and easily and accurately calibrated compass is extremely important.

Measuring your altitude

So we've got our position on the surface of the Earth, and we've got the direction we're pointed towards. Now we need our altitude. There are two ways of doing this. Well, really only one way on modern systems.

An older way of doing this was with sonar. On the **AR Drone** (version 1), there was a tiny speaker on the bottom of the multicopter, which sent out a clicking sound. A microphone on the bottom would measure the latency between the emitted sound and when the mic picked it up. Sounds ingenious, but how do you measure this above, say, 15 feet? Or what about on a sound-absorbing surface such as grass or carpet? Also, what about in a gym where sound can echo? This was inaccurate and lead to many mishaps.

The current method of measuring altitude is the same as your standard commercial airliner, using an altimeter that measures the barometric pressure (air pressure). As you travel up in altitude, air gets thinner. Believe it or not, even inches can make a tiny difference in the barometric pressure.

When controlling your multicopter, the throttle stick isn't really a throttle stick. Really, it's a vertical velocity stick. At 50 percent, your multicopter will hold its vertical vector at 0 percent velocity (a hover). Moving the stick up and down makes you ascend or descend. The more you move the stick, the faster or slower the vertical velocity is. The DJI Phantom 2 even has a spring-loaded throttle stick, so you can let go of both sticks, and the Phantom 2 will hold its position on all three vectors.

Needless to say, accuracy and speed are again important. A very sensitive barometer that samples data very fast will keep your multicopter from bobbing around in the sky.

Here's where the method of comparing the data is also very important. If you don't take your altitude into account when figuring out your GPS coordinates, you'll be in trouble. As you go up, you're moving closer to the space (and the GPS satellites). If you don't factor this into the equation to calculate your relative position to the map coordinates on the ground, the calculations will end up being inaccurate and conflicting. Sure, a 3D GPS fix can give you altitude ... but what if you lose GPS (say ... by going indoors). This may lead to instability. So, a guidance system that takes everything into account when figuring out what your multicopter is doing, and what to do to keep it stable, is crucial.

Keep your attitude in check

The attitude of an aircraft isn't how snarky or cheerful it is. It's which way it's pitching, rolling, or yawing. The sensors that can tell your attitude are called accelerometers and gyros. These are placed so that they measure movement on all three axes. Accelerometers measure movements along the three axes (also called **translation**), while gyros measure rotational movements along these axes, pitch, roll, and yaw.

There are two types of accelerometers: piezoelectric and capacitance. Piezoelectric accelerometers (say this three times fast!) are the most common type. It uses microscopic crystalline structures that respond to stress. When stress is exerted on these crystalline structures, electricity is generated. By measuring the polarity and strength of the crystalline structures, your guidance system can determine a direction and speed of movement.

The other type of accelerometer (capacitance) measures the capacitance between microstructures located near the sensing device. As these microstructures move closer to and further away from the sensing device, the capacitance changes. By measuring this capacitance, the guidance system can determine a speed and direction of movement.

Similarly, there are a few types of gyros: Crystal (which works very similar to piezoelectric accelerometers), Ceramic (which uses tiny ceramic columns or prisms), and Silicon (for which the exact structure varies from manufacturer to manufacturer).

The advantages of each type of device are debatable. But what's not is to get a guidance system with the highest speed and sensitivity possible with both accelerometers and gyros. Are we getting a common theme yet with these sensors? Speed and sensitivity. As air currents hit your multicopter, it will tilt to keep its GPS and altitude location. The guidance system needs to know how much it's tilting and how fast. If it weren't for accelerometers and gyros, it could very well flip over and fall out of the sky.

If these sensors don't sense quickly enough, there will be latency when correcting the tilt/roll of the gimbal, and the multicopter could tilt too far and overcorrect. If it overcorrects, it may overcorrect the overcorrection, and so on. This could lead to bobbing and weaving when you want your multicopter to sit still.

So again ... speed and accuracy are key.

The CPU of your brain

So, now that we've seen that speed and accuracy of your sensors is the key, it goes without saying that the speed and accuracy of your CPU is equally important. But ... we're going to say it anyway.

It's important to have as high a clock speed in your CPU as possible. It needs to not just perform thousands of calculations per second ... it needs to make thousands of calculations for correction based on the thousands of sensor data chunks it gets per second. Slow CPUs can lead to overcorrection, and we know that's a problem by now.

It's also important to have those equations as accurate as possible. The programming of your CPU (the firmware) varies greatly from guidance system to guidance system. You'll have thousands of dollars invested in your platform and camera by the time you're done. Do you really want it to make a miscalculation and fly off to China because it thinks that's home, or worse yet ... fall into a crowd of people and kill someone; all because you skimped on the guidance system?

The internet is the best (and worst) thing to ever happen to software development. Companies push out software not ready for prime time all the time, with the thought in mind: "We can release a patch". Having your word processor lock up is annoying for sure. However, having your guidance system lock up, freak out, and cause a crash is tragic. Look for guidance systems that release firmware updates *only* when they're ready. Sure, users are annoyed at a missed release date. But better to wait a couple more months for all the bugs to be worked out rather than have a series of accidents.

With that in mind, also steer clear of "tinkerer" guidance systems. They're great for hobbyists, but if you're looking to use your multicopter for professional work, this is a bad idea no matter how you look at it.

The final choice for guidance

There are many names out there. Paris, ArduPilot, DJI, X-Aircraft ... these are but a few of the brands out there. We'll cover these brands (as they are fairly popular) as we make our decision.

X-Aircraft

In all fairness, I haven't messed with the X-Aircraft flight controllers for several years. However, based on my experience ... you can hardly blame me. I had the FC1212-S controller with the GPS option. One day I was trying it out with Beastcopter Mk III (a redundant octocopter), and it decided to freak out when I connected the battery. It took off, chopped up my shins, and made a run for my children. I ended up grabbing it, and throwing it at the ground to break the props. I still have the scars on my shins that look like I was attacked by a Cuisinart.

Furthermore, the sensors were slow, the computations were slower, and it was a very unstable aircraft.

ArduPilot (APM:chopper)

The reputation of ArduPilot is excellent. It is open source so that tinkerers can play. However, there are official releases of the firmware as well. This is the Linux of guidance systems. The community contributes to the source code, and if something is relatively safe, it's made part of the next release. They're reasonably priced, but I still have to construct an aircraft ready for production. I have several aircraft in "prototype" phase. I'm not saying they aren't good. I've just found DJI to be superior. That brings us to our next manufacturer ...

DJI

These are the big boys on the block. The makers of the world's most popular turnkey multicopter (the Phantom 2), the DJI reputation is relatively untarnished. Sure, the S800 was a complete pile of garbage, but their guidance systems are amazing, they have good support, and the success of the Phantom is legendary. We'll be using a DJI guidance system.

There are three choices when considering DJI: Naza-M, WooKong-M, and A2. Naza-M is essentially what is inside of the Phantom 2. Extremely stable and great for smaller multicopters. WooKong-M is the former flagship of DJI. It has a much higher clock speed than Naza-M and is better suited for larger platforms. A2 is their latest and greatest guidance system. It's very expensive, but very reliable and an incredible guidance system.

As we're all about balance, we'll use WooKong-M for this example. However, if you have it in your budget, I'd highly recommend the A2. WooKong-M is available at `http://www.empirerc.com/dji-wookong-multi-wk-m-multirotor-controller-with-gps-p-6338.html`.

The weight of WooKong-M is 118 grams, so we'll add this to our weight for a total of 2709 grams of airframe weight. The following screenshot shows our current calculations:

So, we don't have enough lift. It's looking as if we need more RPM from our motors. Remember that RPM is measured in KV. Let's go up to 4S batteries and give them each 8000 mAh to keep it in the air longer. The following screenshot shows these results:

Great! We're back up to 7 minutes of flight time. The batteries are available at `http://www.hobbyking.com/hobbyking/store/uh_viewitem.asp?idproduct=16226&aff=492101`. Considering the weight we'll be hauling around, this is actually really good compared to our cost.

The human interface

This is highly subjective. People prefer different radios. One thing is definitely important, use something with a lot of range and fidelity. The old days of analog FM transmitters are over, and they're completely inadequate for our needs. Your transmitter should be digital, reliable, and have a good range.

For these requirements, there are really only two choices: Futaba and Spektrum. For our example, we'll be using a Spektrum system. I've found that the interface on the controller to set up Spektrum is a bit easier. I own both types of radio systems, and in the end, Futaba has sat on a shelf and gathered dust for quite a while.

We'll need at least seven channels on our radio system. A channel is defined as one item of control for our purposes. Our channels will be throttle, yaw, pitch, roll, stabilization mode (GPS on/off, attitude only, and failsafe), flight mode, and camera tilt. We'll get into stabilization modes and flight modes in the next chapter.

This leaves two controllers as options: Spektrum DX7s and Spektrum DX8. Our receiver will be the eight-channel Spektrum AR8000 receiver. As I already have a DX8, this is the transmitter we'll be using in this example. The weight of the receiver is negligible, so we won't bother adding in a gram or two to our weight.

The DX8 transmitter is available at `http://www.amazon.com/DSMX-Transmitter-Only-Mode-SPMR8810/dp/B00I82EK4E/ref=sr_1_2?ie=UTF8&qid=1401053419&sr=8-2&keywords=spektrum+dx8`.

The AR8000 receiver is available at `http://www.amazon.com/Spektrum-SPMAR8000-AR8000-8-Channel-Receiver/dp/B00402304M/ref=sr_1_1?ie=UTF8&qid=1401053469&sr=8-1&keywords=ar-8000`.

The final component list and cost

Here's what we're looking at (as of May, 2014):

Quantity	Item	Cost
1	Turnigy H.A.L. Multicopter Frame	$63.90
6	Turnigy Multistar 4830-480KV 22-pole motor	$245.94
6	Turnigy Multistar 45-Amp ESC (opto)	$110.76
3	Carbon Fiber 14x7 LH and RH pair propellers	$84.30
4	Zippy Flightmax 4S 8000 mAh battery	$235.20
1	Photoship One mkTR Professional Gimbal with landing gear	$494.94
1	DJI WooKong-M	$1,199
1	Spektrum AR8000 receiver	$129
1	Spektrum DX8 transmitter	$299
	Total cost	$2,862.04

Summary

Wow, what a long journey. Congratulations, you've made it this far! We've learned all about the components of our platform and how to go about choosing them. We've learned about the significance of each part and how to balance power, weight, and flight times. Finally, we've compiled a list of parts to put together our multicopter. This is the same list I used for my Beastcopter Mk VII. It represents about 30,000 USD in investments in parts, upgrades, and learning over many years. Again though, this only represents a thought process, and this particular multicopter may not suit your needs. You now have the knowledge and tools to calculate your own multicopter using your own specifications to custom-tailor your platform for your purpose.

In the next chapter, we'll learn about assembling our multicopter and getting it ready for its maiden flight.

4
Assembling Your Drone

So we've got a handle on how multicopters work and we've got our components. Now, let's see how they all fit together and how we can program our multicopter for flight. The exact tools you'll need vary from system to system. But a general rule would be a full set of both metric and US Allen wrenches, a setup for soldering, some red and black power wire, needle-nose pliers, a set of jeweler's screwdrivers, standard and Phillips screwdrivers, CA glue, and kicker. All of these items should be readily available at your local hobby store. You should also have some experience with soldering, and a modicum of a mechanical inclination. If not … bribe a friend with these traits to help you. Let's get started.

Building the airframe

We've been tossing around the term **airframe** a lot. If you're not familiar with this term, you've probably guessed by now that when we say "airframe" we mean the chassis of the aircraft. You've also probably gleaned that strength and rigidity are key for the airframe. We don't want any play, flex, or floppiness in the aircraft (while keeping the weight as light as possible).

With all of that understood, it's important to follow the directions when putting together your airframe. I know … it sounds obvious. You'd be surprised though. Never get lazy when building and maintaining your airframe.

Here are a few tips to keep all your parts together, and never feel like saying "ah ... we don't need that":

- Set up your assembly where you can work on it for several days without moving it:
 - Dining room tables are bad. Where will you eat? Plus it will upset your spouse/partner/roommates ... trust me.
 - A good direct light source is a must!
- *Never* set up your assembly on carpeted area:
 - Little screws and nuts will be impossible to find if dropped (even with a magnet).
- Sweep up before you start:
 - You don't want to go looking for a dropped nut and get sidetracked by a pebble or dust bunny.
- Get together all of your tools before your start, and keep your parts organized:
 - Organization is the key. A lot of parts (especially small bolts) look similar and will appear to fit. If you don't keep them organized, you may find you're short on parts later down the line. Getting up to get tools is annoying and frustrating.
 - Quality tools (and the right ones) are a must. Using shoddy tools (or improvising with the wrong ones) can damage parts.
- Take breaks!
 - The quickest road to a mess-up is a tired mind. You've made a big investment, and you're eager to try it out. However, this is a complicated piece of machinery. Don't get in a hurry to push through and finish. The airframe is the biggest pain of assembly, and it should not be rushed.

Again, I know ... this all seems obvious. But really, don't underestimate how your excitement will make you take shortcuts. Remain calm, remain relaxed, and most importantly, don't be in a hurry.

Connecting components

The components need to be connected in a proper order. Before we get into exactly how to connect the components, let's take a look at what goes where. The following diagram shows the order (from left to right) that components should be connected: from the battery (left) to the motors (right).

You may notice that the connections on the motors alternate in their sequence of wires. There is a reason for this. Let's talk a bit about how a brushless motor is connected.

Connecting a brushless motor

First, *do not* put any propellers on your motors until you are ready to fly. During assembly, you may spin up motors at times; having props attached could lead to disaster if you're not ready to fly.

In some cases, you may need extension leads for your motors to reach the ESC, or even adapters (if the bullet connectors differ in diameter). You'll also notice that brushless motors have three leads rather than a simple positive and negative lead (as a brushed motor would have). It's pretty self-evident how the motor plugs in. Just match up the colors. However, what if you want the motor to go in reverse? Just switch any two of the leads.

The following image shows a brushless motor plugged in (left) to spin in one direction and then (right) to spin in the opposite:

Finally, on your motor leads ... you'll be tempted to run the cables through the inside of the spars to keep everything tidy. However, you'll be kicking yourself if a motor ever burns out and you need to get in to check your connections, or rerun lines. I use Velcro straps to hold the connectors and cables to the bottom of the shafts. The previous image shows the cables on top of the shafts. They were only placed there to facilitate photography. I would never fly with the cables on top (as if a prop comes loose, it could cut cables, or cause a short). Also, use the right thickness of cables. Using cables that are too thin for your current can cause serious damage, or even melt off the rubber coating and cause shorts. Using wires that are too thick will weigh down your multicopter unnecessarily.

What's a CAN bus?

No ... it's not a renovated school bus for recycling tours. In simple terms, DJI equipment (and a few other systems) uses this type of a bus as a chain of components. The CAN bus allows DJI equipment to be placed on the bus, is added on to your system, and is the communication channel for these components. You'll notice a CAN hub between the PMU and the GPS/Compass module. There is a slot left open for components such as the iOSD (onscreen display for FPV flight), or a Datalink module (the Datalink module allows you to control your multicopter via a laptop or iPad). The CAN bus makes expansion, customization, and fully-autonomous flight possible. Just think of it as the "yes-you-CAN bus." If you're using a different product, it may have a different protocol (such as 12C). Either way ... they do the same job.

Placing the sensors

The **Internal Measurement Unit** (**IMU**) is the module that contains the accelerometers, gyros, and the barometer. As it detects the movement on all three axes of possible rotation, it should be placed as close as possible to the center of the aircraft. Whatever controller you use, the sensor package should have this placement. If you think about it, if the package is placed at the front of the aircraft and it tilts to move forward, the barometer will register that the aircraft dipped down in altitude a few inches (as the front end moves down as the back end goes up). It's important for accuracy to make the registered axis of movement the same as the mechanical axis of movement. Also, you should make sure the arrow on top of the IMU module points toward the front of the aircraft, and mount this unit on a soft rubber pad (as vibration can cause false readings).

The GPS/Compass module is susceptible to magnetic fields (as a compass works by sensing the Earth's magnetic field). The motors work by what again? That's right, by using electromagnetic fields in alternating polarity to move traditional magnets radially. So, the magnetic fields put out by the motors can affect your compass readings. You'll want to place the GPS/Compass module up and out of the rotational plane of the electric motors by a few inches. The airframe we've chosen for this example has a tall dome, so no extension is necessary. You should also make sure the arrow on the module points toward the front of the aircraft. The following image shows the Beastcopter Mk V (which uses a carbon fiber rod to hold the GPS/Compass module above the plane of the motors):

Programming your guidance system and remote

Before attempting to program your multicopter, you should first and foremost make sure you don't have any propellers attached to your motors. Also, make sure you've installed all your software (that came with your guidance system) on your laptop.

Connect your USB cable to your multicopter, and get ready ... it's time to power on your multicopter for the first time. Turn on your radio control unit, and then connect your battery. Don't be alarmed if you hear a sudden loud beep. This is your ESCs using the magnetic fields of your motors to let you know they are connected and working.

> If you see any smoke, hear a fizzle, or smell something funny ... disconnect your battery *immediately*. This means you have a short somewhere. If you allow electricity to continue flowing, you could start a fire. So, needless to say ... conduct your programming in a safe environment with a laptop computer. Make sure you also have an Internet connection available.

Now that your multicopter has power, start the programming software on your laptop.

Update!

After the software links up with your multicopter, you may get some notices on the screen telling you that updates are available. If so, please follow the instructions and update your computer's interface software, and then (if updates are available) your guidance system's firmware. We've chosen DJI as our controller primarily because they have a reputation for putting reliability over estimated release date of firmware updates. So, we generally trust them. However, it's always a good idea to check with the online community to see if anybody has had issues with updates before taking a chance.

Chapter 4

Exploring the WooKong software

When you open the WooKong software, you'll be confronted with the main screen. This is simply a status screen letting you know how your WooKong is currently set up. As the default settings are pretty much irrelevant to your system ... at this stage, we can move on to the basic configuration screen. The following screenshot shows the main screen:

Assembling Your Drone

Setting your motor configuration

WooKong-M (and just about every other guidance system) is capable of controlling several different configurations. Here is where you tell the guidance system how your motors are arranged. The following screenshot shows the motor configuration screen of the WooKong software interface:

As you can see in the screenshot, the top of each drone image represents the front of the aircraft. The motors are sequenced counterclockwise from M1 through M6. Clicking on the **Motor Test** button opens the motor test interface. Click on the motors one by one, and make sure that the correct motor spins and in the correct direction when clicked.

If the wrong motor spins, you'll need to check the Mx plugs on the WooKong main controller. Just switch the plugs until the correct motor spins. If it's spinning in the wrong direction, just change the motor leads as described earlier to change the direction of the spin.

Mounting

The **Mounting** screen is where you can correct the placement of your IMU and GPS modules. The compass must be pointed forward, and this is not something you can correct. If you accidentally pointed the IMU in the wrong direction (provided it's at some multiple of 90 degrees from forward), you can set the correct orientation using the software. But really, the best use of this part of the software is to tune the system to know exactly where (in relation to the center of the hub) the sensors go. If you've had to set the IMU a little back or forward of the center, you can measure (in centimeters) from the center of the hub to the center of the IMU on each of the axis, and then input the measurements into the software here. Similarly, you can measure from the center of the hub to the GPS and input those measurements as well. This is extremely important to prevent oscillations, or even loss of control. The following screenshot shows the **Mounting** screen:

RC calibration

The **RC** screen is where you make sure your sticks move the aircraft in the right directions. You should set your **Receiver Type** to **Tradition**. As you move the command sticks vertically, at the bottom, the corresponding **T** for throttle should be at the left when your throttle stick is down and to the right when it is up. Similarly, the **E** should be at the left when your elevator stick is down and should be at the right when it is up. If either of these moves in the opposite direction, either reverse those channels on your remote or click on the **REV** button next to that channel.

You should set your Aux 1 on your remote to a three-position switch. This will let you switch between **GPS, Atti.,** and **Failsafe**. The **Atti.** (non-GPS / attitude-only stabilization) mode would be used in case you fly indoors, or in an area where GPS signals are not available. This will also let you set the multicopter into a panic (failsafe) mode if things go haywire or you lose orientation. From your remote, you should be able to set where the needle shows what mode you are in on the **Control Mode Switch** area of this screen. The settings on a Spektrum DX8 transmitter should be made in the travel parameters. The following screenshot shows the **RC** screen:

We'll leave the **Gain** screen at default until after our maiden flight.

Motor settings

When your multicopter is powered up, you cannot immediately take off. First, the motors must be armed. Upon arming the motors, they spin up to idle. As we have a very powerful multicopter that generates a lot of lift, we do not want the idle speed to make our multicopter take off. In the **Advanced** section, under the **Motor** tab, set the **Motor Idle Speed** to **Low**.

Similarly, when landing, you can either set the motors to power off immediately when you set the throttle all the way down, or go down to idle for a bit and then cut off. Immediate cut off can be dangerous if you accidentally throttle all the way down while in the air. You'd have to rearm the motors before you can recover—something you're unlikely to achieve before a crash. So … set the **Cut Off Type** to **Intelligent**. The following screenshot shows the **Motor** screen:

Let's not worry about calibrating the **Gimbal**, **IOC**, or **Limits** until after the maiden flight. Instead, let's set the voltage of our batteries.

Assembling Your Drone

Setting up your batteries

A part of this process will be taken care of during our maiden flight, but first we need to let the system know how much voltage it's going to have to deal with. The settings here are simple for the time being. Leave the **Loss** at **0.00 V**, and set the **Safeguard** option in the **First Level Protection** section to **LED Warning**. Also, set the **Battery Type** to **4S LiPo**. The following screenshot shows the **Voltage** screen:

Summary

Well, there it is. We built our multicopter, but the journey isn't over just yet. There is a lot of calibration yet to be done before we can lay a modicum of trust in it. We assembled it and prepared it for its maiden flight. Do you have a name for it yet? If so, I don't blame you. A ton of work, research, and yes ... love goes into building your first multicopter.

In the next chapter, we'll build your skills up! We'll get you ready for your maiden flight and get you as prepared as you can be. We'll get the multicopter into a hover and finalize the calibration of our gimbal and our batteries. We'll also learn about safety precautions and some general rules to minimize the risk to your equipment, investment, and yes ... the public.

5
Flying Your Multicopter

So you've built your multicopter and you're ready to get in the air and shoot some video, right? No. We have a long road ahead—calibrating your multicopter and honing your piloting skills.

Get a simulator!

It can't really be said any simpler. There are several good RC simulators on the market. However, only one stands out as a viable multicopter training device. It is RealFlight. RealFlight Version 6 and above have built-in multicopters you can play with and even fly FPV. RealFlight is available at `http://www.realflight.com`. The following screenshot shows RealFlight in action:

Flying Your Multicopter

The screenshot shows a Gaui 330X quadrocopter being flown by yours truly. Getting a simulator is paramount to your flying. Even though I am an experienced pilot, I put in a few hours every week on my simulator practicing maneuvers. The multicopters in RealFlight do not have all of the stabilization of a good guidance system. However, this is a good thing.

This is similar to a baseball batter in the box swinging two bats before he gets up to the plate. When he gets to the plate, he's more than ready to swing one bat. If you can get your flying in a simulator stable and smooth … the results when you get in the field will be far better. Also, a simulator lets you crash, fly in high wind, and try new moves without endangering your investment. Shelling out 150 USD for a good simulator sure is better than crashing a 3,000 USD multicopter. (Not to mention the liability of what you may crash it into.)

Thinking in three dimensions

I know … obvious. However, this is another reason for the simulator. You may be used to driving a car or even a motorcycle … but these vehicles move in 2D. Flying (especially a hovering aircraft) is in 3D. Just like you needed education and practice to make driving second nature (you don't think about applying brakes, throttle, or steering a car … you just do it), you need even more practice to make flying an extension of yourself. Additionally, when a model is flying toward you … you'll need to practice how the controls work differently.

Furthermore, you need to keep your skills up once you've acquired them. For your sake, your aircraft's sake, and the general public's safety … practice regularly. You need to not just build your muscle memory, but keep practicing and keep the feel of flying fresh in your mind.

Safety

Remember that a multicopter is more like a flying food processor than an RC toy. There are a lot of considerations to take into account when choosing where, when, and how you're going to fly. Consider the following checklist as a guideline for safety … the foundation you should build even more rules from for yourself. This checklist is the basic set of rules to minimize your risk and keep you out of most legal hassles.

Where to fly

Let's face it; multicopters are cool ... super cool. So, you're going to draw a crowd if you fly where people gather. So, although a park may sound like a good idea ... it's not. If possible, find an actual RC flying club in your area. If there isn't a club in your area, find a large open space with no people or property you could possibly damage.

Calibration flights (such as your maiden) are especially dangerous. Fly-aways, sudden flips, or component failures are far more likely to occur during these flights. Don't invite friends or family to watch. During shoots, you may have a director or client want to watch. If this is the case, the safest place for someone to stand is behind you (the pilot) in relation to where the aircraft is. You're instinctively likely to do anything you can to keep the aircraft from hitting you. If an observer is behind you, the aircraft would have to hit you to get to them (and you won't be distracted by wondering where they are).

A nice flat area (such as a valley or plateau) is the best place to fly. You don't want to be fighting unpredictable wind currents when you're calibrating your multicopter.

It is illegal to fly near airports in the US. For your safety, and the safety of others, don't fly within 5 miles of an airport. Check with your local authorities for actual altitude and distance limits around airports if this 5 mile barrier cannot be achieved.

When to fly

In the middle of the day, the ground is warmed up by the sun. During the night, it cools. Warming and cooling of ground can cause thermal wind currents. So, the best times are usually not the middle of day or night. The morning is usually less windy and has best visibility. Early in the morning, with the sun at your back, is when you should take your maiden flight.

How you should fly

In a word ... conservatively. Use the simulator to push your skills. In the real world, there are real consequences. Don't push any bad situations (if something doesn't feel right ... wave off, or don't attempt it). Stay a bit afraid, but not so afraid that you become hesitant. If you're not afraid of losing your equipment or hurting someone, your focus could stray and you could become dangerous. Confidence is good, but respect for the dangers associated with flying a multicopter is a must. Complacency is bad.

The preflight checklist

Before you fly and every time before you fly, you should run through your preflight checklist. Would you be comfortable on a commercial jet if they didn't inspect the aircraft before every flight? No. Similarly, you should not be comfortable flying your multicopter without checking through your list ... every time you connect a battery.

The following list illustrates the steps you should go through when you're getting ready for a flight:

- Check props for tight mounting. Loose props can lose power or even fly off in midflight.
- Check all your connections to make sure nothing is loose.
- The motors should be snug on their mounts. Any screws can loosen from the vibration and stress of a flight. This is especially true on the motor mounts.
- Check all airframe parts for a snug fit. As stated in the previous step, screws can loosen from flight stress. They can also loosen due to temperature differentials. Any unexpected flex or play in the frame can cause a failure. Also check for any cracks/dents.
- Spin each motor with your finger. If any motor feels rough (not just the magnetic attraction) or significantly different from the other motors, you may need to replace that motor due to scarred or chipped bearings.
- Check your guidance system for snug mounting. Also, check that the components are facing the proper direction. Any play on guidance system parts can lead to a crash.
- Turn on your remote control transmitter. Make sure your controls are all in the idle position.

- Connect the battery to your multicopter (and if you have a power switch, turn it on). Listen for the ESCs to make their start up beeps. An unusual sound may indicate a power short.
- Calibrate your compass as indicated by your guidance system's instruction manual.
- Wait for the GPS lock. Every guidance system needs time to lock to the minimum number of satellites for a flight. On the WooKong-M, this means waiting for the red flashing lights to stop. Skipping the GPS lock and not calibrating the compass is the reason for most multicopter crashes.

Your multicopter's maiden flight

Are you ready to get this thing in the air? Let's do this. You should have your laptop and guidance system interface cable (USB cable) with you. The batteries you use should also have a full and fresh charge on them (within 24 hours of flight, they should be charged). We'll be conducting several flights as a part of the maiden. The first one will be a battery calibration flight.

Battery calibration

When your multicopter spins up and takes off, that is called *putting a load* on your batteries. Even though your batteries are full, immediately your voltage will drop. In order for your guidance system to know when power is getting low, it needs to know what your load differential is. This is the difference between the resting voltage of your batteries and the load voltage. For that reason, either mount your camera to the multicopter's gimbal, or something that is of equivalent weight. (For your maiden flight … I advise you to use a weight.)

Turn on your laptop, connect it to your preflighted multicopter, and start up the DJI software. Go to the **Voltage** screen and make sure that **LED Warning** is selected in the **First Level Protection** area. Make sure you hit *Enter* on your keyboard to write the change. Disconnect the multicopter from the USB cable and prepare to take off.

Flying Your Multicopter

What we're going to do is hold the multicopter in a hover until the guidance system indicates a battery warning (flashing yellow light). Then, we'll immediately land and plug the guidance system back in and get a battery voltage reading. It'll be important to note the current voltage field in the software. The following screenshot shows the **Voltage** screen:

We'll fill in the **Loss** section after this flight. Let's get your multicopter in the air ...

Arming and flying your multicopter

As you get ready for your first flight, let's arm the multicopter. To keep something bad from happening by accidentally bumping the throttle before you're ready to fly, most multicopters are equipped with an arming protocol. DJI guidance systems use a protocol that makes you put your control sticks in opposite bottom corners. To arm our multicopter, we'll use the stick positions as illustrated in the following image:

Once you arm your multicopter, the motors will spin up to idle. Now, it's time to get your multicopter into a hover (and out of ground effect).

What is ground effect?

Ground effect is when the ground below you creates a high pressure zone under an aircraft. Ground effect will also change the shape and size of the wind vortices formed by the spinning blades. The result of the ground effect is a reduction in drag and an increase in speed. This effectively makes hovering a bit easier. Fixed wing pilots will report a change in an aircraft's feel as more of a "floating feeling". It will also yield lower stall speeds in fixed wing aircraft.

Flying Your Multicopter

Mathematically, ground effect can be defined as being closer to the ground than the wing span of an aircraft. This is a bit more difficult to calculate with a multirotor aircraft. A safe bet is that ground effect is the entire span of the multirotor aircraft set on its side. The following diagram shows a simplified ground effect. Granted, with a multirotor it is significantly more complex than this ... but you get the picture.

Although a hover is achieved easier in ground effect, we want to get out of it fairly quickly. This is because we want our barometer to be free of high and low pressure zones that may be caused by ground effect vortices. On a multicopter, hovering within ground effect could potentially lead to bobbing. So, when we lift off, we'll increase our throttle slowly until the skids come off the ground, and then give a tiny bit more thrust to lift up between 1-2 meters off the ground. Then, we'll return our throttle to the middle.

Remember, our guidance system thinks of throttle as vertical velocity (rather than throttle). In the middle is a hover. Below the middle is down and above middle is rise. The following image shows the control sequence to get into a hover. This is based on using the common mode 2 type controller (throttle on left).

Arm	Lift Skids	Lift OGE	Hover
Both sticks to opposing bottom corners	Left stick up slightly above center	Left stick up slightly more until OGE	Left stick center to hover

Once you are in a hover, and **Out of Ground Effect (OGE)**, watch that LED indicator from the WooKong-M. Do not look away. This could take anywhere from 5-15 minutes. You need to wait for that LED indicator to blink yellow. As soon as you see that blinking yellow light, ease the throttle down slightly, land gently, and drop the throttle all the way down. After a few seconds at idle, the motors will stop. Do not disconnect your battery and do not turn off the controller.

Do not delay. Plug your laptop back into the WooKong-M and it should link back up. Take a look at that current voltage. It will be higher than the **First Level Protection** voltage. However much higher that number is, put that difference in the **Loss** section of both the **First Level Protection** and **Second Level Protection** areas. For instance, if the voltage reading for **Current Voltage** reads **16.10 V**, you should enter `0.7` in the **Loss** field of both the **First Level Protection** and **Second Level Protection** areas. This is because our **First Level Protection** voltage was set at **15.40 V**. It triggered and we landed, but our actual voltage was **16.10 V**. This makes our load voltage differential 0.7 V.

Congratulations! Your voltage is now calibrated! Now, either charge these batteries back up, or break out the spares and do another flight. On your second flight, move the multicopter around a bit. Keep it just out of ground effect (between 1 m and 2 m altitude) and get a feel for the controls.

Watch out for prop wash

No ... prop wash is not a cleaning solvent for propellers. Prop wash can be simply defined as the wind currents put out behind the propellers (in this case ... below the aircraft). If you descend too fast, you're likely to fly through your own prop wash. Prop wash is filled with turbulence and thin air. If you fly through prop wash, you could wobble (at best) or even crash (at worst). So, if you descend ... go slow. If you must descend fast ... fly forward or in spirals to keep your prop wash away from your movement vector. For instance, if you fly forward while descending rapidly ... your prop wash will be behind you, rather than underneath you.

Take it slow

This is where you take over. The next several flights will be to get a feel of your machine. Remember though ... tiny movements on the sticks—infinitesimally small. If you get going too fast, you're probably going to overcorrect and smash into something very hard. It'll be easy for you to gain too much confidence too soon. Remember to take things very slow. You should fly for many days at low altitude and slowly increase the maneuver complexity and altitude. Because a multicopter is symmetrical, it will be very easy to lose orientation (forget which way it is facing), panic, and crash.

By keeping things slow and starting by walking behind your multicopter while you're learning to fly it ... making it move will become second nature. At this point, you're conditioning your brain to use the multicopter as an extension of yourself. An infant can't run a 4-minute mile. You can't fly like a professional (yet). You'll get there. Be patient.

Summary

You're a pilot! Congratulations. For the most part, your multicopter is calibrated and ready to go. Once you have built up your confidence enough and have completed a few flights without crashing, you can move on to the next chapter. In the next chapter, we'll be discussing calibrating your gimbal to keep your camera level, mounting FPV gear, and talk about how to fly using FPV.

6
First Person View (FPV) Gear

Okay, now you've got your multicopter flying, and it's time to shoot some video. Usually, the whole point of using a multicopter is to use it as a camera platform. So, what good is it if you can't see what the camera sees? Any serious multicopter imager needs an FPV system to be effective. Let's take a look at how these systems work.

Components of an FPV system

There are really only five main components of an FPV system:

- The camera
- OSD (onscreen display)
- Video transmitter (TX)
- Video receiver (RX)
- Monitor

Let's take a look at these one by one. The following image shows you the wiring diagram with an added FPV system so that you can see how it fits into the grand scheme of things (the bottom-left section of the figure):

The Camera

There are so many cameras in the market that can suit your needs. Recommending a camera can be a whole book by itself. So rather than getting into specific models, let's take a look at a few specifications you should look at.

CCD versus CMOS

The whole reason HD cameras have gotten so small and power-efficient is the CMOS chip. Far more cameras use CMOS than CCD sensors to convert light to data. The main difference is that CMOS sensors scan from the bottom-up while CCD sensors capture an entire frame (image) at once. This scanning (by the CMOS chip) method can lead to what's known as **shutter roll** or **jello**. The following image is a screen capture from a YouTube video by Ramon Panzavolta (https://www.youtube.com/watch?v=DB740lEkEkg) that illustrates the difference when panning fast with CCD (left) and CMOS (right). I suggest that you watch this video.

Chapter 6

This can also create strange results with any vibration in the multicopter. Any vertical line on the image captured will begin to squiggle. For this reason, you'll either want a very fast CMOS sensor (which scans fast enough to minimize this effect), or an HD camera with three CCD sensors. 3CCD cameras use an individual CCD sensor for each color (RGB), giving you a very clear picture. The following image shows you the 3CCD logo that you should look for when deciding on a CCD-based camera:

The camera should also be lightweight, and the lens should be easy to clean (as you'll need to clean the lens for every flight).

Onscreen display (OSD)

Some pilots call this a **heads-up display**. Simply put, it overlays telemetry data from your guidance system to the video feed coming from the camera. At a glance, you can tell what your multicopter is doing—usually its position in relation to where it took off from—and information such as the current battery charge. It gets this telemetry data by hooking directly to the guidance system. The OSD does not affect the video/images recorded on the camera and only transmits that data via the FPV system. The following image shows you what an OSD can provide. I have used the DJI iOSD mini.

The transmitter and receiver

It's important to use a different frequency than your control's receiver to minimize risk of jamming the signal for control. As both Spektrum and Futaba use 2.4 GHz for their frequency, we'll use a 5.8 GHz video transmitter by Immersion RC. This transmitter is light, has 600 mW of transmission power (giving it a decent range), and is available at http://www.hobbyking.com/hobbyking/store/uh_viewitem.asp?idproduct=17507&aff=492101.

The receiver should be of the same brand as your transmitter (as they all use slightly different frequency variations) in order to make sure they're compatible. Also ... check to make sure that the frequency (and strength) your transmitter uses is legal in your part of the world. You should not use goggles (such as Fat Shark) until you are very experienced at FPV flying. You don't get depth perception with goggles, and if something goes wrong, your eyes will be blinded by the difference in light when you take them off. So, a receiver that has a video output is crucial (rather than just a set of goggles with an antenna). The Immersion RC receiver is available at http://www.hobbyking.com/hobbyking/store/uh_viewitem.asp?idproduct=41147&aff=492101.

Finally, a regular stick-style antenna is not adequate for FPV. You want something that has the same sensitivity and power in any direction. Therefore, a cloverleaf antenna set for both the TX and RX is also crucial. The following image shows you a clover-leaf antenna mounted to the bottom of a DJI Phantom 2. The 5.8 GHz clover-leaf antenna I use is available at `http://www.hobbyking.com/hobbyking/store/uh_viewitem.asp?idproduct=49827&aff=492101`.

Video monitors

As most of the time you will be flying outdoors, it's important to choose a monitor that is bright and has a lot of contrast. It should also be capable of having power from a battery (DC) and be mountable to your remote (therefore, it should also be light). Finally, it should have a sunshade (cover to shade the screen from sun glare). The monitor I use is inexpensive and works very well. It is available at `http://www.hobbyking.com/hobbyking/store/uh_viewitem.asp?idproduct=28907&aff=492101`, and the mount for the remote is available at `http://www.hobbyking.com/hobbyking/store/uh_viewitem.asp?idproduct=40608&aff=492101`.

Some general guidelines

FPV flying is a subject of hot debate. Some feel that there is a lot of potential for invasion of privacy and malicious use of this technology. Therefore, don't become a target of these debates.

Rules for flying

Some of these rules are grounded in common sense. Most are law. It's important to remember, above all else, your priorities:

1. Safety for the public.
2. Following the law.
3. Safety for your aircraft and camera.
4. Getting the shot.

Shifting your priorities out of order opens you to injuring people, property, and possibly criminal/civil consequences. Remember ... every RC aircraft has a clock. They will eventually crash. By following your priorities and best practices, risk of liability/injury/loss is greatly reduced. It's not if ... it's when.

Priority 1 – safety for the public

By following these dos and don'ts, your risk of injury and liability can be greatly reduced:

- *Never* fly over unsuspecting crowds.

 People you fly over must be aware that there is a multicopter flying overhead, and they must be warned if something goes wrong.

- *Never* fly within 10 feet of a person (line of sight) or 50 feet of a person (FPV):
 - Even a simple fluctuation in Earth's magnetosphere can cause your drone to shift position by 10 feet in any direction
 - When flying FPV, the pilot has no perception of depth, and a 50 foot barrier is the minimum for safety

- When shooting streets, stay to the side of a street:
 - Dropping out of the sky over a public street can cause a serious hazard
 - Again ... make sure you're not flying over civilians

- *Always* remember the following:
 - A multicopter has no glide. If motors fail ... it drops from the sky like a rock.
 - Drones can freak out. This is not a jib arm nor a Steadicam that is rooted to the ground. If the guidance system has an error, or it shorts out ... it can tumble anywhere.
- Never fly within 3 miles of an airport, and don't go over 300 feet in relative altitude within 5 miles of an airport.
- *Never ... ever* push a bad situation. If something feels wrong ... divert your aircraft away, examine the situation, and only if deemed safe ... try it again. Even if this means purposefully smashing your multicopter into the ground, or into an open field. Don't endanger people nor property. Remember that public safety is your first priority.
- When possible ... have a spotter while you fly. You can't watch a screen and your aircraft at the same time.
- Survey your area before you fly.

Priority 2 – follow the law

Drones are in a lot of legal questions. Don't be the next story that justifies a blanket law making them illegal. Follow these dos and don'ts:

- Check regularly for updates to Federal (FAA), State, and Local laws and ordinances regarding the RC aircraft and drone technology. The **AMA (Academy of Model Aeronautics)** is a great source for this information. You can visits the AMA website at `http://www.modelaircraft.org/`.
- Never fly over private property without permission.
- Never point your camera into backyards at a low enough altitude to make people recognizable. Invasion of privacy is a very hot issue for drones.
- Don't fly over municipalities and city streets.
- Stay below a relative altitude of 500 feet at all times.

Priority 3 – safety for your aircraft and camera

What good is a shot if you destroy your camera or aircraft? Follow these rules:

- Fly a simulator regularly:
 - Do not attempt maneuvers in the real world that you haven't mastered in a simulator first
- Keep practicing:
 - Put in at least two hours of flight time a week for practice
- Never descend straight down (especially rapidly):
 - Descending through your own prop wash can throw off your sensors and make your multicopter crash itself
- Conduct regular maintenance as outlined in your owner's manual
- Don't fly with chipped blades:
 - This can cause vibration that will make your sensors crash your multicopter without notice
- Don't fly below 26 percent battery

Priority 4 – get the shot

Notice that this is your last priority. Keep that in mind. If something goes wrong ... you never want to say "I was just trying to get the shot" as an excuse. This is no excuse and should be your very last priority. If you disagree ... you should *never ... ever* be flying.

Summary

Our multicopter is now ready for prime time. We've got some experience in flying, we have our video system ready to roll, and it's time to learn the moves to get great shots. In the next chapter, we'll cover advanced flying techniques to get the footage that will make your clients and friends drop their jaws and get very excited.

7
Camera Flying Techniques

We've built our multicopter, tuned it, set up our camera, and even tested it out. That was all fun and good, but this is where you'll be giggling as if you're 8 years old again. Getting amazing shots with your multicopter never gets old, and with some patience and practice, you could be shooting just like the pros (and maybe even become one yourself). In this chapter, we'll be talking about the fundamental camera moves that you can combine to get great results, how to fly indoors, and even converting your multicopter to a fully-autonomous drone.

Executing camera moves

The biggest mistake I've seen pilots make is not moving through a shot. The problem is usually because RC pilots with no camera or editing experience throw a camera on a multicopter and go for it. In the visual effects industry, what we're going for is called a **handle**. Basically, this is starting a shot before what you think will be the in-point of a clip and ending it well after the estimated out-point. This gives an editor some space to play with the timing. For instance, if your goal is to move sideways past a person, you should start with the person well off the screen and end with them well off the other side of the screen. Don't ever say "got it!" to yourself and veer off. Move *through* the shot. With this in mind, let's talk about the camera moves you'll need and how to execute them.

Crane shots

One of the best parts about multicopter flying is that you can replace extremely expensive equipment such as cranes (known as jib arms) with a relatively low-cost multicopter and get amazing results. A jib is limited by the length of the arm, its radius, and its leverage. A big jib can cost thousands of dollars per day to rent out, can take several people to operate, and can take hours to set up and break down. A multicopter is free from all of these constraints.

Camera Flying Techniques

In simple terms, a crane-style shot is one where you start at one elevation and move to another. For example, we may start low in front of a building, move towards it, and rise over the top of it. Or, we may move sideways doing the same thing, or even drop down from above a building to reveal the entrance as an establishing shot. An advanced form of a crane shot could be to point the camera straight down at an actor playing dead and to slowly rise and yaw (spin slowly) in order to give the illusion of the spirit leaving the body. The applications of this shot are as limitless as the permutations. In this example, we'll talk about starting low and moving forward to rise above a building.

These are the simplest types of shots. All you have to do is get into a hover, just shy of where you want the shot to start, and push forward on the right stick. This starts your forward movement. Then, push forward on the throttle stick, and you'll rise above your target. Keep moving for a second or two after you think you've got the shot. The important part to remember is to use tiny movements on the sticks. Tiny, gentle movements will produce the best results, as they'll minimize bumps in the footage and make it easier for you to avoid hitting obstacles. Remember, large movements can get you into trouble very quickly. The following image shows the crane shot we're illustrating here:

Dolly shots

These shots can be simple (forward or backward) or complex (side dollies). A dolly is another piece of traditional camera gear that can be easily replaced by a multicopter. A dolly is just a platform with wheels on which a camera can be mounted. Usually, there are one or two people pushing the dolly, with a camera operator riding the dolly. So, a multicopter dolly shot is simply about maintaining an altitude and moving in any horizontal direction. Side dolly shots are notoriously difficult to take when flying FPV because you can't see where you're going nor easily judge the distance to an obstacle. It's easy to drift too close or too far away.

A dolly shot is executed by moving your right stick in any direction, while using the yaw stick to keep the lens pointed in whichever direction you wish, and your throttle to maintain the altitude. Again, remember to move *through* the shot. The following image shows an example of a backward dolly shot (moving backwards). You can see the huge advantage here because we can fly over a counter (where wheels would stop or the track would be visible).

Camera Flying Techniques

Fly-through shots

These are visually impressive and very technical shots. You must be precise and gentle on the sticks to even think about attempting these shots. A fly-through is where you literally fly through a gap in an obstacle or between obstacles. Again, FPV (as it is not stereoscopic) has no depth perception; so, you may want to think about having a spotter (another observer) to watch your multicopter to tell you to back off and try again if you start heading for an obstacle. These shots require a lot of practice to get it right, and a simulator can be a great help here. Don't attempt these shots until the sticks are second nature and you don't have to think about the controls. For example, you should be thinking "up" instead of "left stick push up". Also, remember that you don't have to go fast. Slow, steady, and gentle will take you much further. You can always speed things up in post (editing) if you want to zoom through some obstacles. The following image shows a fly-through using a gap between the branches of a tree:

Orbit-by shots

An orbit-by is where you move in a somewhat arced path while facing the camera either inside or outside of the center of the arc to keep a subject in the frame as you move. An inside orbit-by is usually good for either architecture or people, as it adds an element of dynamic movement to static objects. It can also be used to make a moving target seem as though it's going even faster (as the speed with which you pass the object is usually multiplied by your speed because you're moving in opposite directions).

An outside orbit is good for high-speed moving objects (such as cars or motorcycles). These moves can be difficult, as you're moving both the sticks constantly to maintain your path and direction. The following illustration shows what an orbit-by path would look like:

So, with this outside orbit-by, we're moving in the opposite direction from our motorcycle. We could do this in the same direction to slow things down. The following image shows this same movement in action:

The 360 orbit

By far, this is the most difficult move to get right. It's not difficult to physically orbit something. In fact, the stick moves are fairly easy. However, it's difficult to keep the movement smooth while keeping your distance consistent and your target on the screen. This is especially true if you're using a 2-axis gimbal (as I do). Why use a 2-axis gimbal? This is because I like to know in exactly which direction the nose of my aircraft is pointed at all times. That's a point of personal preference though, not any industry standard. A lot of pilots prefer a 3-axis gimbal.

Ok, tangent over. A 360 orbit is where you completely circle a target. The 360 orbit is really pretty simple. Just move both the sticks horizontally in opposite directions. The tighter you want your orbit, the more you'll pitch forward (push forward on the right stick). It's extremely important to do these slowly and gently (especially, tight orbits) as you can get disoriented, cause bumpy footage, or smash into obstacles. Slow, gentle, and tiny movements are the key.

The easiest way to perform a 360 orbit is by maintaining a yaw rate (the constant position of the left stick horizontally) and by making all of your adjustments with your right stick (speed and distance to target).

The following image shows an example of an orbit:

For a complete demonstration of these techniques (using RealFlight so that you can see the stick moves), check out a video I have done on this subject for the *Videomaker* magazine at https://www.youtube.com/watch?v=_D04pSOeJGk. Moreover, if you'd like to see all of the actual shots from the previous stills, they're compiled at https://www.youtube.com/watch?v=rnujaCRAhFI.

Indoor flying considerations

Indoor flying can be hazardous, to say the least. Obstacles, debris, and prop-wash are all very dangerous. Here, more than anywhere, is where it's important to go very slowly.

Before you begin your flight, you'll want to check for items that could get blown about. If you can't run a leaf blower in the room you're flying in ... you can't fly. Indoors, I've lifted and flung area rugs across the room, seen ancient dust bunnies come out of the woodwork, and had papers shredded in my blades. I learned the hard way to do this check before I fly indoors.

You'll also want to consider possible air currents. Stay away from the walls. You'd think that walls would create a buffer of high pressure and push you away. The opposite is true. The closer you get to a wall, the more it tries to suck you in towards it. The same goes for ceilings too. Any obstacle can create a wind current. Analyze the room, and try to predict any wind currents that could disrupt your flight.

Finally, remember that you don't have a GPS signal. The gyros and accelerometers are doing all of the heavy lifting here. The barometer can't even be fully trusted, and compasses can be thrown off by the EM (electromagnetic fields) generated by appliances or even the structure of the building itself. You're going to drift, so vigilance is crucial. If you're flying from the indoors to the outdoors, remember that your GPS will reconnect as soon as it's able to. For this reason, take your multicopter outside and calibrate the compass; let the GPS lock before you bring it inside. Do this right outside the door/window out of which you'll fly out. If you don't, your guidance system will think that you've drifted far away from where you had your last GPS lock, and it will try to correct this. This will cause a huge bump in your footage, and possibly a crash. Whenever possible, fly in from the outdoors and reverse the footage (in the editing) instead to completely eliminate this risk.

Experiencing an autonomous flight

First, I don't advise anyone to do this if they value their multicopter. Relinquishing the control of your multicopter is certainly a pucker moment, to say the least. DJI makes a few Datalink modules that connect directly to the CAN bus for autonomous flight and telemetry. The 2.4 GHz Bluetooth Datalink lets you control your multicopter with an iPad and even set waypoints on a predetermined path to turn your multicopter into a true drone. The following image shows the iPad interface and the Datalink module:

This tech is completely inappropriate for professional videography or cinematography. So why would anyone use it? There can be several applications, but one I can think of is a farmer wanting to inspect his fields. A multicopter can be set to patrol his farm slowly and return home. He can view the HD footage and look for any watering issues, brown patches, or inconsistencies in the crops—all without the need to learn to fly and while sipping an iced tea on his porch. The footage won't be smooth and stable (especially in turns), but it will be viewable for analysis purposes. An example of an autonomous flight with the Beastcopter can be viewed at https://www.youtube.com/watch?v=QqBYZ9_IW10. This is a fully autonomous flight (from take off to landing) with three waypoints. Notice that as each waypoint is reached … it is very bumpy.

Summary

Now you're truly a multicopter pilot! Well, once you've mastered these skills. However, congratulations are still very much in order. You've learned all the major moves to shoot your video; however, you're not a pro yet. There's one skill left to learn before you can pitch your services at a production company. You'll need to provide edit-ready stabilized footage. In the next chapter, we'll discuss the post processing of your footage and culling it into usable clips for deliverables to clients.

8
Post Processing

We've learned about multicopters. We've flown some flights, and even shot some videos. Now what? We need to prepare our video for delivery to our client (or just get it ready to edit it ourselves). Although our gimbal does quite a bit of the heavy lifting to stabilize our footage, we'll still need to run some software stabilization to make it smooth as glass. We'll be using Adobe Premiere Pro CC 2014 for this example.

Cutting your clips into segments

Believe me ... you don't want to try to stabilize an entire flight at once. It will take far too long, and any jerky moves you make in setting up a shot will greatly affect the quality of the shots you want to keep.

This is because during stabilization, the video is moved around on the screen to make it smooth, and to keep a black box from showing at the edges ... the video is scaled up. Scaling up a video creates a slight loss in the resolution. The greater the scale ... the greater the loss. The more jerky the movement, the more the stabilizer will have to move the video around, and the greater the scale. So, needless to say, use small clips.

You can create smaller clips (called subclips) easily in Premiere Pro. Follow these steps:

1. Load your footage in the preview (left) monitor. (Either drag the footage in from the bin, or double-click on it.)
2. Scrub it to your in-point (drag the time indicator), and mark the in-point (hit the *I* key on your keyboard).
3. Scrub or play your video to an out-point and mark it (hit the *O* key on your keyboard).
4. Drag the video (grab the displayed video using your left mouse button) in to your bin and descriptively name it.

Post Processing

The following image shows the preview window with in/out-points marked:

The following image shows the bin with the new subclip added to it and named:

Easy enough? Just run through your footage, and identify the clips that you may want to use and add them to the bin. This will make editing much easier.

Using Adobe's Warp Stabilizer

Warp Stabilizer is a visual effect. Therefore, it must be used in the timeline. If you load the clip in the timeline (just drag it in) and apply the **Warp Stabilizer** plugin (just type warp in the search bar in the **Effects** panel, and it will pop up) by dragging the plugin onto the clip in your timeline, Premiere Pro will begin the process of stabilizing the clip. Although your program monitor will say that it's stabilizing in the background … this process is *very* processor intensive, and it's usually just better to wait for it to finish rather than risk a crash by trying to do too much at once. The following image shows the **Warp Stabilizer** plugin processing our clip:

Wait! Once it's finished ... there is a black box around our clip. This is because we're shooting racing motorcycles. **Warp Stabilizer** has mistakenly seen our fast pan (to keep the bikes in view) as instability. So, it's had to scale up so much that it's gone beyond its maximum limit (150%). In fact ... the calculations are so screwy that the motion is less stable than the original. The following image shows the black box:

This can usually be fixed by turning down **Smoothness**. This parameter is less about smoothness and more about how much **Warp Stabilizer** does to affect the image. If we turn **Smoothness** down to **5%**, our video becomes as smooth as butter. If you run into jumpy or weird looks by using **Warp Stabilizer**, just try lowering **Smoothness** until you get the result you are after. The following image shows the new settings:

Summary

Congratulations! You have completed this book and are on your way to becoming a great multicopter pilot! We've learned about components, the physics of flight, and how to build/fly our multicopter. We've even learned about stabilizing the video we've shot! I wish you the best of luck in flying, and thank you for your time and patronage.

Index

Symbol

360 orbit, camera moves 96, 97

A

accelerometers
 about 52
 capacitance 52
 piezoelectric 52
Adobe
 Warp Stabilizer, using 103-105
airframe, multicopter
 about 10
 battery, selecting 40, 41
 building 59, 60
 carbon fiber, versus aluminum 32-34
 ESC, selecting 38-40
 motor, selecting 36-38
 propellers, selecting 34, 35
 selecting 32
 specifications, tweaking 42-44
aluminum airframe
 versus, carbon fiber airframe 32-34
AMA (Academy of Model Aeronautics) 89
AR Drone (version 1) 51
ArduPilot 54
autonomous flight
 experiencing 98, 99
 URL 99
axes of rotation, aircraft
 pitch 7
 roll 7
 yaw 7

B

Battery Eliminator Circuit (BEC) 40
battery, multicopter
 selecting 40, 41
 URL 56
brands, multicopter guidance system
 ArduPilot 53
 DJI 54-56
 Paris 53
 X-Aircraft 53
brushless gimbals 46
brushless motor
 connecting 61, 62
budget expectations
 about 24
 realistic expectations, setting 24

C

camera
 about 27, 84
 CCD 84, 85
 CMOS 84, 85
camera gimbals
 about 15
 brushless gimbals 46
 servo gimbals 46
 using 44-47
camera moves
 360 orbit 96, 97
 crane shots 91, 92
 dolly shots 93
 executing 91

fly-through shots 94
orbit-by shots 95
CAN bus 62
capacitance accelerometers 52
carbon fiber airframe
versus, aluminum airframe 32-34
cavitation 36
CCD, camera
versus CMOS 84, 85
Ceramic gyros 52
clips
cutting, into segments 101-103
CMOS, camera
versus CCD 84, 85
compass 50
components, FPV system
camera 84
onscreen display (OSD) 86
receiver 86
transmitter 86
video monitors 87
components, multicopter
brushless motor, connecting 61, 62
CAN bus 62
connecting 61
list and cost 57
sensors, placing 63
configuration, multicopter rotors
independent 30
redundant 30
CPU 53
crane shots 91, 92
Crystal gyros 52

D

DJI 25
dog running 50
do it yourself (DIY) multicopters 29
dolly shots 93
DX8 transmitter
URL 57

E

eCalc
URL 31
electronic speed control (ESC), multicopter
about 12
selecting 38-40

F

First Person View (FPV system)
components 83
flat configuration. *See* independent configuration
fly-through shots 94
FPV flying
rules 88
Futaba 56

G

Gaui 330X quadrocopter 74
gimbal 44
Global Positioning System (GPS) 48, 49
GoPro shooting 26
GPS/Compass module 63
ground effect, multicopter 79-81
guidance system, multicopter brain
about 13, 14, 48
brands, selecting 53
CPU 53
sensors 48
gyros
about 52
Ceramic 52
Crystal 52
Silicon 52

H

handle, camera 91
heads-up display. *See* onscreen display (OSD)
human interface 56, 57

I

Immersion RC receiver
 URL 86
independent configuration
 about 30
 versus, redundant configuration 30
indoor flying 97, 98
inside orbit-by shot 95
Internal Measurement Unit (IMU) 63

J

jello 84
jib 91

K

KV 36

L

line of sight (LOS) 6
LiPo (Lithium Polymer) 40

M

mAh (milliamp hour) 41
microphone
 using 51
MikroKopter 25
mkTR Professional gimbal
 URL 46
motor configuration
 setting 66
motor, multicopter
 about 11
 selecting 36-38
 URL 38
motor settings 69
Mounting screen 67
multicopter
 about 5, 6, 10
 airframe 10
 airframe, selecting 32
 arming 79
 battery calibration 77, 78
 camera gimbal 15
 electronic speed control (ESC) 12
 flying 79
 flying techniques 6
 ground effect 79
 guidance system 13, 14, 48
 motors 11
 precautions 82
 preflight checklist 76
 propellers 11
 prop wash 82
 purpose, identifying 29
 radio systems 16
 rotors, determining 30
 safety rules 74
 software updates 64
 transmitters 15
 yaw control 7
multicopter lift 8
multicopter movement 8, 9

O

online communities
 about 22, 23
 RCgroups.com 23
 YouTube.com 23
onscreen displays (OSD) 14, 86
orbit-by shots 95
Out of Ground Effect (OGE) 81
outside orbit 95

P

piezoelectric accelerometers 52
pitch 7
preflight checklist, multicopter 76
propellers, multicopter
 about 11
 selecting 34, 35
 URL 44
prop wash, multicopter 82
puffing 41

R

radio systems, multicopter 16
RC calibration 68
RC simulators
 about 73, 74
 analyzing, in 3D view 74
RealFlight
 URL 73
receiver 86, 87
redundant configuration
 about 30
 versus, independent configuration 30
remote
 programming 64
resources, for reviews
 online communities 22, 23
reviews
 resources 21
revolutions per minute (RPM) 36
roll 7
rotors, multicopter
 configuration 30
 determining 30
rules, FPV flying
 aircraft safety 90
 camera safety 90
 don'ts 89
 dos 89
 priorities 88-90
 public safety 88, 89

S

safety rules, multicopter
 flying location 75
 flying technique 75
 flying time 75
segments
 clips, cutting into 101-103
sensors
 altitude, checking 52
 altitude, measuring 51
 compass 50

Global Positioning System (GPS) 48, 49
 placing 63
 using 48
servo gimbals 46
shutter roll 84
Silicon gyros 52
smaller clips
 creating 101
software updates, multicopter 64
specifications, airframe
 tweaking 42-44
Spektrum 56
Spektrum AR8000 receiver
 URL 57
subclips. *See* smaller clips

T

TestPilotRC channel
 URL 23
toilet bowling 50
translation 52
transmitter 86, 87
trolls 23
trusted brands
 about 25
 cameras 27
 for GoPro shooting 26
Turnigy H.A.L. (Heavy Aerial Lift)
 hexacopter frame
 about 34
 URL 34
turnkey system
 need for 19, 20

U

Unmanned Aerial System (UAS) 6

V

video monitors
 about 87
 URL 87

W

Warp Stabilizer
 using 103-105
WooKong-M
 URL 55
WooKong software
 batteries, setting up 70
 exploring 65
 motor configuration, setting 66
 motor settings 69
 Mounting screen 67
 RC calibration 68

X

X-Aircraft 54

Y

yaw 7
yaw control, multicopter 7

Thank you for buying Building Multicopter Video Drones

About Packt Publishing

Packt, pronounced 'packed', published its first book "*Mastering phpMyAdmin for Effective MySQL Management*" in April 2004 and subsequently continued to specialize in publishing highly focused books on specific technologies and solutions.

Our books and publications share the experiences of your fellow IT professionals in adapting and customizing today's systems, applications, and frameworks. Our solution based books give you the knowledge and power to customize the software and technologies you're using to get the job done. Packt books are more specific and less general than the IT books you have seen in the past. Our unique business model allows us to bring you more focused information, giving you more of what you need to know, and less of what you don't.

Packt is a modern, yet unique publishing company, which focuses on producing quality, cutting-edge books for communities of developers, administrators, and newbies alike. For more information, please visit our website: www.packtpub.com.

Writing for Packt

We welcome all inquiries from people who are interested in authoring. Book proposals should be sent to author@packtpub.com. If your book idea is still at an early stage and you would like to discuss it first before writing a formal book proposal, contact us; one of our commissioning editors will get in touch with you.

We're not just looking for published authors; if you have strong technical skills but no writing experience, our experienced editors can help you develop a writing career, or simply get some additional reward for your expertise.

[PACKT] PUBLISHING

Lightning Fast Animation in Element 3D

ISBN: 978-1-78355-938-1 Paperback: 136 pages

Master the intricacies of Element 3D, the fast-rendering Adobe After Effects plugin

1. Create enthralling and polished 3D graphics using Element 3D.
2. Explore the overall workflow in Element 3D, including transforming objects, applying materials, and lighting scenes.
3. Fully illustrated and written in a conversational manner.

Mastering Adobe Premiere Pro CS6 Hotshot

ISBN: 978-1-84969-478-0 Paperback: 284 pages

Take your video editing skills to new and exciting levels with eight fantastic projects

1. Discover new workflows and the exciting new features of Premiere Pro CS6.
2. Take your video editing skills to exciting new levels with clear, concise instructions (and supplied footage).
3. Explore powerful time-saving features that other users don't even know about!
4. Work on actual real-world video editing projects such as short films, interviews, multi-cam, special effects, and the creation of video montages.

Please check **www.PacktPub.com** for information on our titles

Mastering Adobe Captivate 7

ISBN: 978-1-78355-988-6 Paperback: 532 pages

Create interactive SCORM-compliant demonstrations, simulations, and quizzes with Captivate 7

1. Enhance your projects by adding interactivity, animations, sound, and more.
2. Deploy e-Learning content on a SCORM, AICC, or a Tin Can-compliant LMS.
3. Publish you project in a wide variety of formats including Flash and HTML 5.

Image Processing with ImageJ

ISBN: 978-1-78328-395-8 Paperback: 140 pages

Discover the incredible possibilities of ImageJ, from basic image processing to macro and plugin development

1. Learn how to process digital images using ImageJ and deal with a variety of formats and dimensions, including 4D images.
2. Understand what histograms, region of interest, or filtering means and how to analyze images easily with these tools.
3. Packed with practical examples and real images, with step-by-step instructions and sample code.

Please check www.PacktPub.com for information on our titles